TEXT BY
Olivia Snaije

PARISIAN CATS

PHOTOGRAPHY BY
Nadia Benchallal

Flammarion

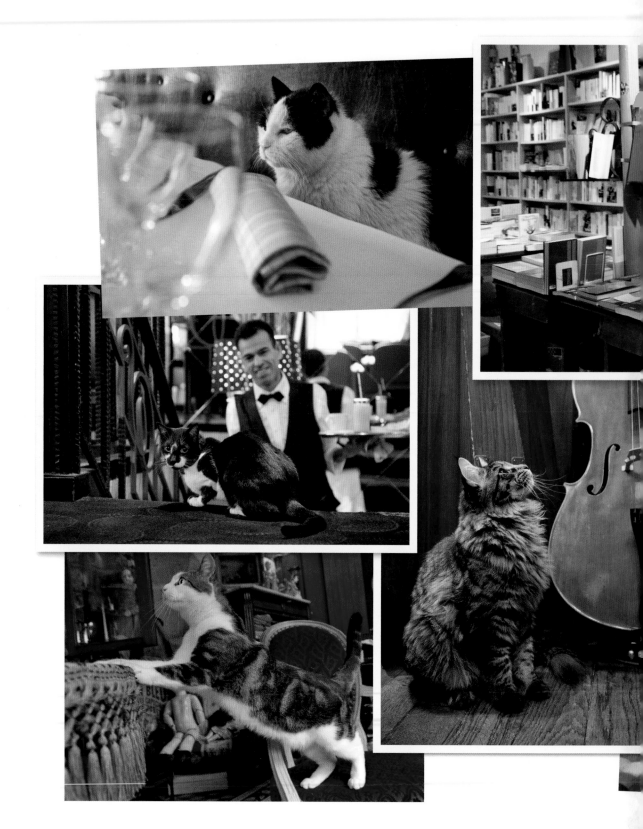

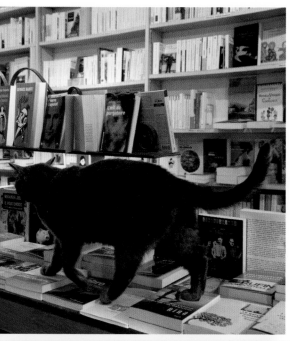

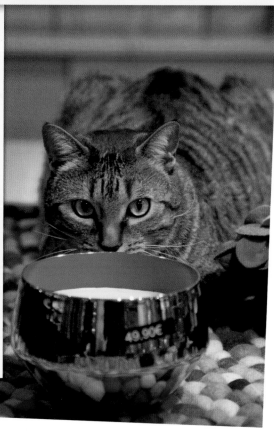

CONTENTS

INTRODUCTION

Paris, unlike Rome or Cairo, is not a city immediately associated with cats. And yet, once you begin to look around, cats are everywhere. Not in gangs eating pasta, or dotted around a marketplace, but cozily ensconced in a basket in the corner of a restaurant, lazing in the sun in a gallery window, or fast asleep atop a bistro dessert case.

The inspiration for this book came about after seeing these alluring creatures in shops and cafés that are central to Parisian daily life. These cats have not only become the mascots of their establishments, they live in the city's loveliest or most historical and culturally rich neighborhoods, spending their days roaming seventeenth-century gardens or cavorting in the nineteenth-century Grand Palais. By observing and photographing the cats in their everyday lives and speaking to the people who care for them, we embarked on a feline odyssey throughout the city, rediscovering and re-imagining it from a cat's point of view.

Cat lovers will notice these animals in various shapes or forms all around Paris. In the Montparnasse cemetery, for example, Niki de Saint Phalle's giant, colorful, mosaic tombstone of a cat is impossible to miss. Also omnipresent are cats in Paris cafés, bistros, and restaurants. Unlike most Anglo-Saxon countries where health codes prohibit animals in eating establishments, in France pets are forbidden only in the kitchen itself.

Like all urban areas, Paris has a mouse problem, and many café cats were initially acquired to control the rodent population. Very soon, however, the cats became the pride and joy of their establishments, charming customers and attracting newcomers. But some cats—like

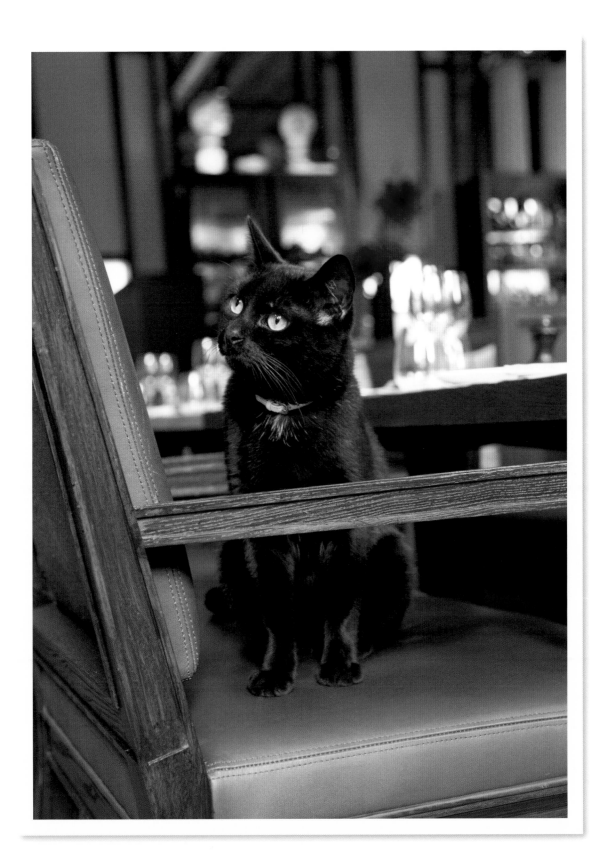

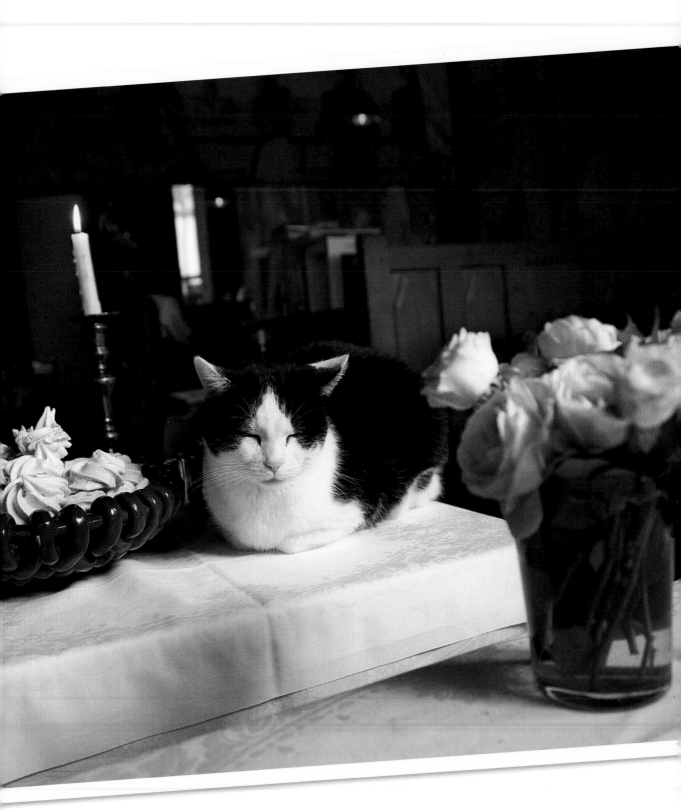

Mickey, who was Le Select café's cat for over two decades—arrived of their own accord and simply decided to stay, confirming the adage that you don't choose a cat, a cat chooses you.

In selecting which cats to include in this book, one often led to another, and after a while there was no telling where it would end. On the Left Bank, we were told about Swiffer, the cat in Le Café Zéphyr on the Right Bank. We learned about Zwicky, a cat living at Fleux—a chic design store in the Marais—from a nearby bookshop. An employee at a Parisian stained-glass studio called frequently to alert us to new cat sightings. And soon we found cats everywhere.

Being cats, of course, they have all carved out a very pleasant existence for themselves and have adapted in the best possible way to their Parisian environment—whether at a busy crossroads such as the Café RUC near the Palais Royal and the Louvre, or across the street from the lovely Luxembourg Gardens at the café Le Rostand. Some cats have the neighborhood attuned to their needs: if Arthur from the bookshop Page 189 wants to get into the building next door, he heads to the adjacent Italian specialty shop, and meows until the owner comes out from behind the counter and punches in the door code to let him in. While preparing the book, we had to adapt to the cats' schedules, waiting for certain felines to return to Paris after their summer vacations in the country.

Parisian cats are also ubiquitous in art and literature. French novelist Colette immediately comes to mind: the original cat woman, she wrote about her beloved pets in her novels, letters, and memoirs, and lived her last years in an apartment overlooking the Palais Royal Gardens, surrounded by felines. Her friend, the writer, artist, and filmmaker Jean Cocteau lived around the corner and loved cats too; they provided inspiration for several of his paintings, sculptures, and poems. Photographer Robert Doisneau's black-and-white images of Paris in the 1950s included many cats, pictured with concierges, sitting next to vagabonds, or slinking along the city's rooftops at night.

The most iconic Parisian cat appears on Steinlen's oft-reproduced nineteenth-century poster for Rodolphe Salis's famous Cabaret du Chat Noir. Imagine our delight when we discovered by chance that a black cat named Salis lives in the Montmartre museum, which has a collection dedicated to memorabilia from Le Chat Noir cabaret.

The irresistible cats in this book lead the reader on a singular tour of the French capital, uncovering its rich history and beguiling locations along the way. Cats, those featured here and their successors, form an integral part of the Parisian landscape and add undeniable character—dignified and zany, independent and affectionate—to the City of Light.

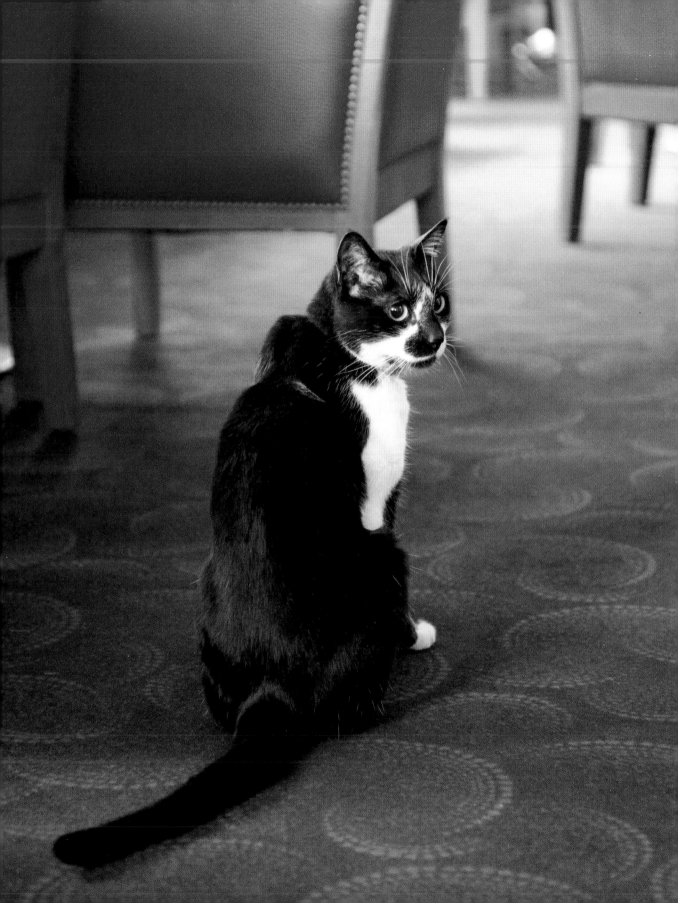

With a slight stretch of the imagination, one can conjure up what the Roaring Twenties might have been like in this nineteenth-century café-brasserie. Au Père Tranquille is a former cabaret located next to the once-great marketplace Les Halles. An advertisement flyer from the 1920s, which the current owners found in the cellar and reprinted, shows an elegant couple, the man in a top hat, getting out of an expensive car and being shown into the supper club. Besides dancing, singing, wining, and dining, Au Père Tranquille promised entertainment from midnight until morning.

Today's schedule is more sensible—the brasserie opens early and closes at midnight. Vanille, the resourceful black-and-white cat who has belonged to the establishment since 2005, is strategically fed at closing time, ensuring that she will return from her wanderings and be safely inside before the staff leaves.

Au Père Tranquille is located on a street named for a sixteenth-century Renaissance architect, Pierre Lescot, who worked for a succession of kings for thirty-three years, adding on to the Louvre palace, as well as designing the nearby Fountain of the Innocents (Fontaine des Innocents). Today, the street, while pedestrian, is always bustling, so the café is rarely empty.

Damien Revel, who began working at Au Père Tranquille in 2002, is one of three managers who alternate at the brasserie. Taking care of Vanille "is part of the job," says Revel, adding that he is the one who takes her to the vet. Vanille, with a white chest and black nose, roams the vast and busy territory of Les Halles, the celebrated twelfth-century marketplace, which inspired the title of Émile Zola's third novel, *Le Ventre*

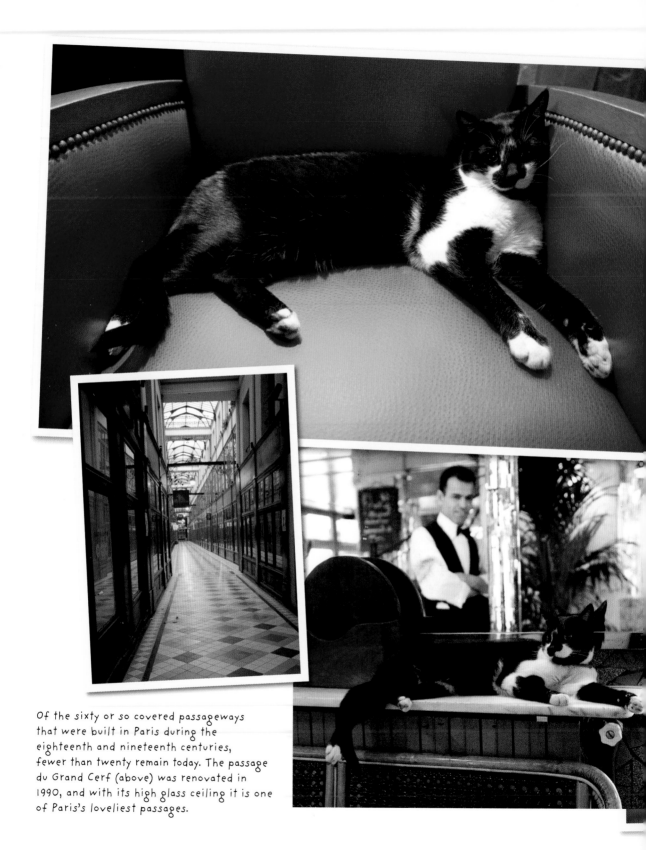

Of the sixty or so covered passageways that were built in Paris during the eighteenth and nineteenth centuries, fewer than twenty remain today. The passage du Grand Cerf (above) was renovated in 1990, and with its high glass ceiling it is one of Paris's loveliest passages.

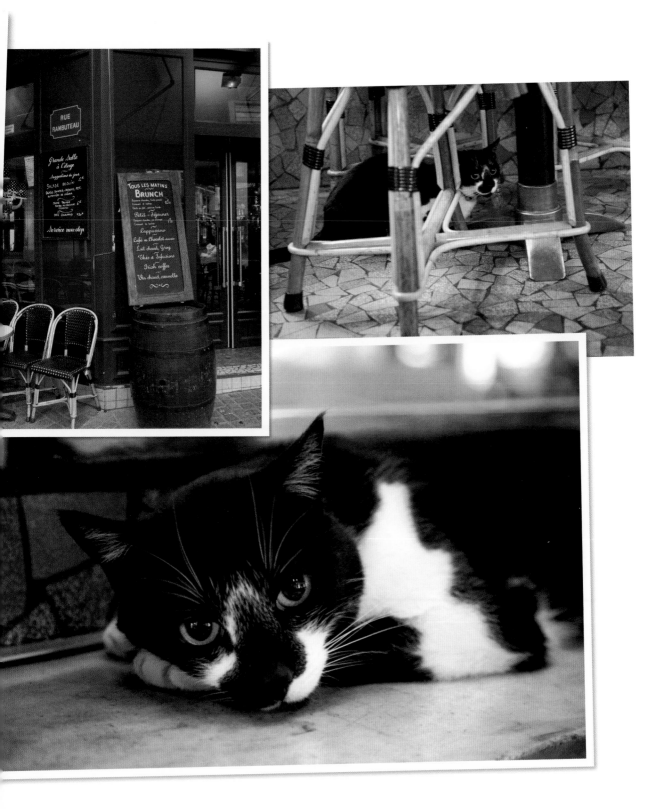

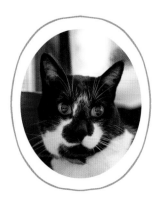

de Paris (*The Belly of Paris*). Les Halles was the bosom of a far-reaching network of food markets that date back to the fifteenth century and remain part of the fabric of Parisian life. Les Halles was also captured by photographer Robert Doisneau, who had been using the market as a source of inspiration since 1933. Doisneau's black-and-white and later color portraits of butchers, fishmongers, and vegetable and flower stalls, as well as the Victor Baltard–designed structure of Les Halles itself, committed the great market to photographic memory.

Perhaps in an atavistic attempt to once again find the atmosphere of Les Halles, which was relocated in the 1970s to Rungis in the southern outskirts of Paris, Vanille once climbed into a delivery truck that was going there. "Someone found her in the market and called us after checking her tattoo," recounts Damien. "We had to go pick her up."

One of Au Père Tranquille's waiters, Sami Ben Hag Sassi, has worked at the brasserie for over thirty years. Slight and nimble-footed, he knows all the regular patrons and points out a musician who sketches Vanille and then makes postcards from his drawings. Another customer regularly brings in nail clippers to deal with Vanille's claws, he adds.

With a shade of annoyance and a tinge of pride, Sami discloses that Vanille sometimes hunts birds and brings them upstairs to the first floor, where there are bookshelves laden with novels, comfortable sofas, and armchairs placed cozily around tables. "Then there are feathers everywhere. Have you ever tried vacuuming feathers from a wall-to-wall carpet?" Most of the waiters have known Vanille since she was a kitten and are used to her wanderings, although she is never far from her home base, where she often settles on the radiators as soon as the weather gets chilly or "on our laps in the office when we're doing the accounts," says Damien.

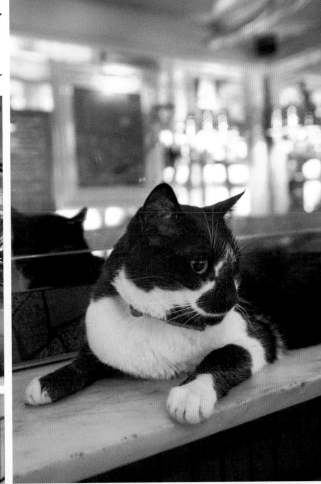

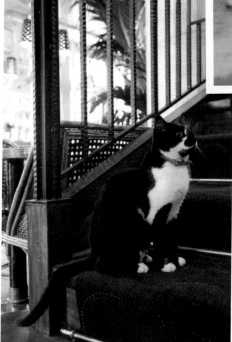

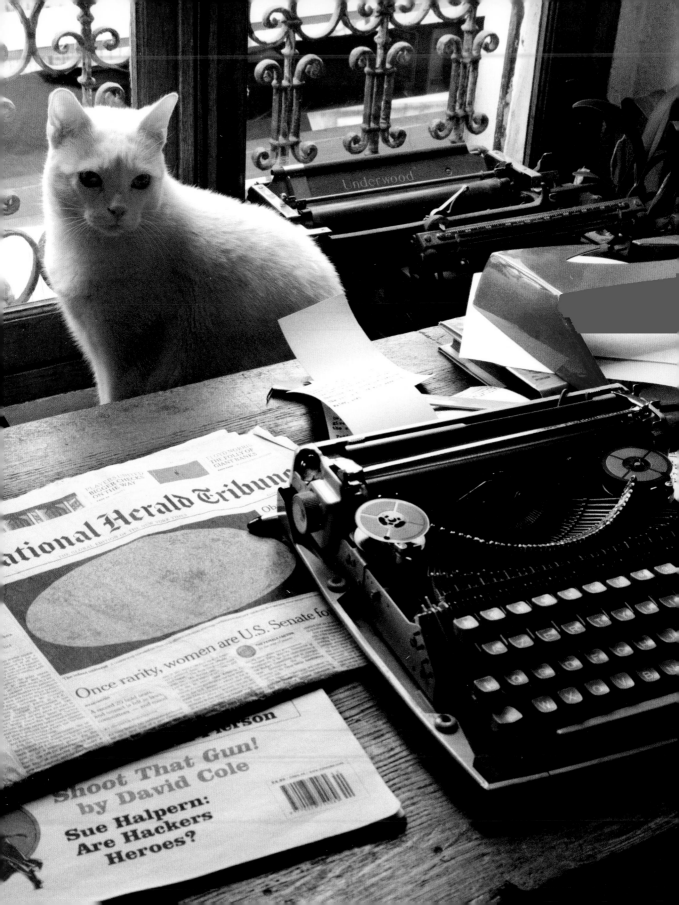

Shakespeare and Company
37, rue de la Bûcherie
75005 Paris
+33 1 43 25 40 93

Kitty

If one were to choose the best-loved Anglo-Saxon institution in Paris, it would probably be the bookstore Shakespeare and Company. Founded in 1951 by the late George Whitman, a transplanted American, the Latin Quarter bookshop overlooks the Seine and Notre Dame Cathedral at Paris's kilometer zero. Whitman adopted the name Shakespeare and Company with the blessing of the legendary Sylvia Beach who had established her eponymous bookshop in 1919 and ran it until the German occupation of Paris during World War II. George's daughter Sylvia (named after Beach) now runs the bookshop with David Delannet, her partner in life and in business. Poets and writers such as Allen Ginsberg, Lawrence Durrell, Henry Miller, Jack Kerouac, and Anaïs Nin, among many others, graced his shop—as did at least seven felines-in-residence over the years, a number of them called Kitty.

"There have always been cats at Shakespeare," says David. The bookshop's current Kitty, a snow-white, blue-eyed male with a bemused expression, was also George's last cat and stayed by his side until his death in 2011 at the age of ninety-eight. Perhaps because the current Kitty was raised by the Whitmans' dog, Colette, he is incredibly gregarious and obedient for a cat and seems at ease among the throngs of customers flowing through the entrance of the shop.

The entry wall is covered with photographs and paintings of famous patrons; among these is a photo of Ernest Hemingway with a cat in his arms. Customers wind their way through the nooks and crannies of the ground and upper floors, some settling with a book on the velvet-covered armchairs, others on a wooden banquette. Kitty likes

Paris's antique booksellers, or *bouquinistes* (below), have been around since the seventeenth century. Today there are 216 *bouquinistes* installed along the banks of the Seine who sell antique editions of books, secondhand contemporary novels, engravings, prints, and magazines, among other items.

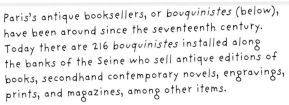

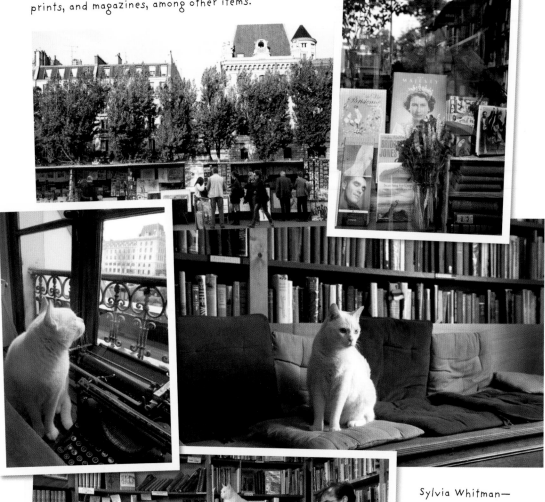

Sylvia Whitman— the daughter of Shakespeare and Company's founder— and her partner David Delannet, with their dog Colette and the late George Whitman's cat Kitty (left).

sitting in places where he has a vantage point: on top of the piano, wedged between the window and an Underwood typewriter behind a desk, or on the highest surface of a bookcase where he often knocks books down. The typewriter has been used by a long list of Shakespeare and Company resident writers known as tumbleweeds, who, in exchange for temporary lodging above the bookshop, must write a one-page autobiography, read a book a day, and help out in the shop.

"Kitty really is very cool," notes David. "He's intrigued by the street but never actually goes outside. He just hangs out. Once, he was on the sofa in the bookshop, and five people were gathered about with someone playing the piano very softly so that it wouldn't disturb him. When you have an animal in a business, it imposes a certain rhythm and silence."

If Kitty were to venture past the welcoming metal green tables, chairs, and wooden benches set up in front of the bookshop and the cast iron Wallace drinking fountain— designed by sculptor Charles-Auguste Lebourg and financed by philanthropist and Parisian-by-adoption Richard Wallace in the nineteenth century—he would find extraordinary monuments on both sides of the shop as well as a small park. This public park, which contains a locust tree that is over four hundred years old, used to be part of the adjoining twelfth-century church Saint-Julien-Le-Pauvre, which replaced an older church from the sixth century. On the other side of the bookshop, just across the rue Saint-Jacques, which leads uphill toward the Sorbonne University, is the gothic Saint-Severin church, named after a hermit from the sixth century. In addition to a lovely fifteenth-century cloister with two immense trees that Kitty would undoubtedly enjoy, the interior of the church features impressive twisted stone pillars that resemble a forest of palm trees. Just beyond the church is the narrowest street in Paris, the rue du Chat qui pêche (the cat that fishes), named, purportedly, after a black cat that belonged to a church canon and would fish in the Seine with its paw.

Kitty may not fish, but it is clear that he is more than just another Shakespeare cat. Many see him as a representation of George's spirit, welcoming book lovers to his shop.

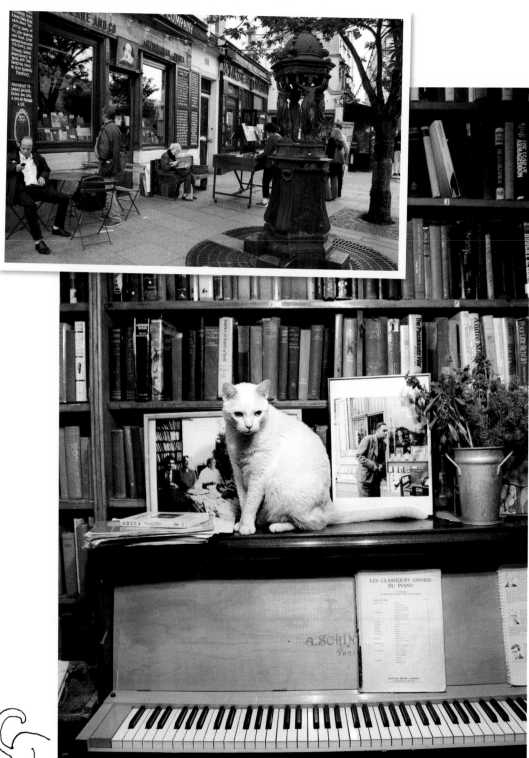

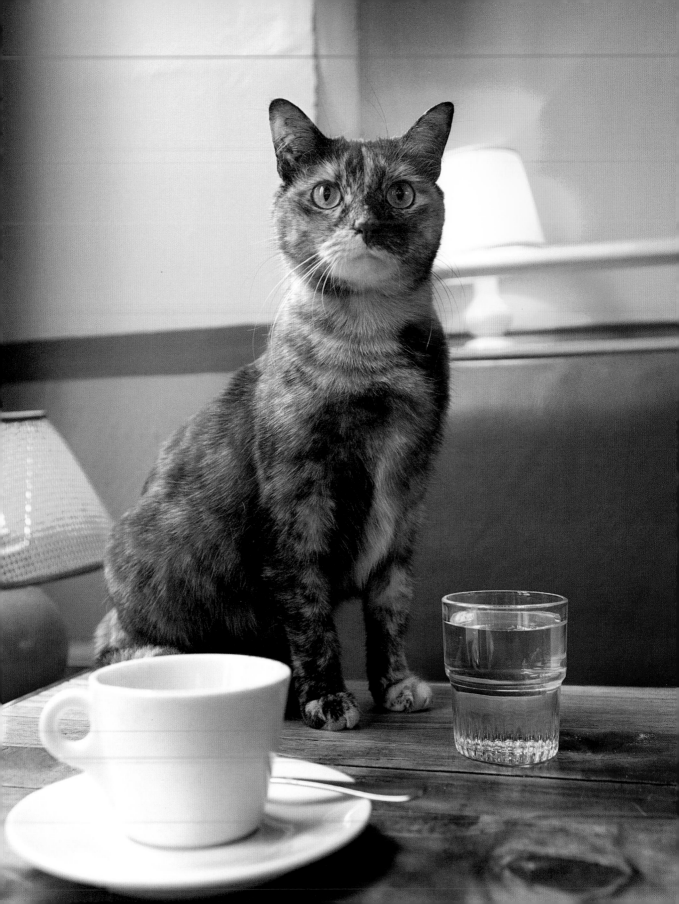

The Café de l'Industrie, a neighborhood institution on the rue Saint-Sabin, is just behind the imposing place de la Bastille, symbol of the French Revolution, where the former medieval fortress and prison, symbols of the monarchy, were stormed by the populace in 1789. The late Gérard Le Flem, an inveterate globe-trotter and painter, opened the café in 1990, maintaining an authentic 1920s feel with an eclectic, haphazard mix of his own paintings and objects he picked up during his travels. A glamorous black-and-white portrait of a youthful Jean-Paul Belmondo by Studio Harcourt, the celebrated Parisian photography studio, hangs next to Gauguin-style paintings by Gérard and an African mask; a Botero-type oil painting complements a bust of an African woman in a turban. Burgundy-colored carpets are thrown over the dark parquet floor, and small lamps give off soft lighting. Gérard's son Benoît, who has worked here since he was a teenager, now manages the café, which has two annexes on the same street. Mimine, a green-eyed calico, has been the house cat since 2002, following the disappearance of a series of stolen or runaway kittens. "She's a little wild," says Benoît, "which is what has saved her. We have one thousand clients coming in each evening, and we've already caught people trying to stick her under their coat."

Cherished by customers, both old and new, the delicate Mimine is self-contained and discreet—she decides which patrons to adopt and when. She alternates between

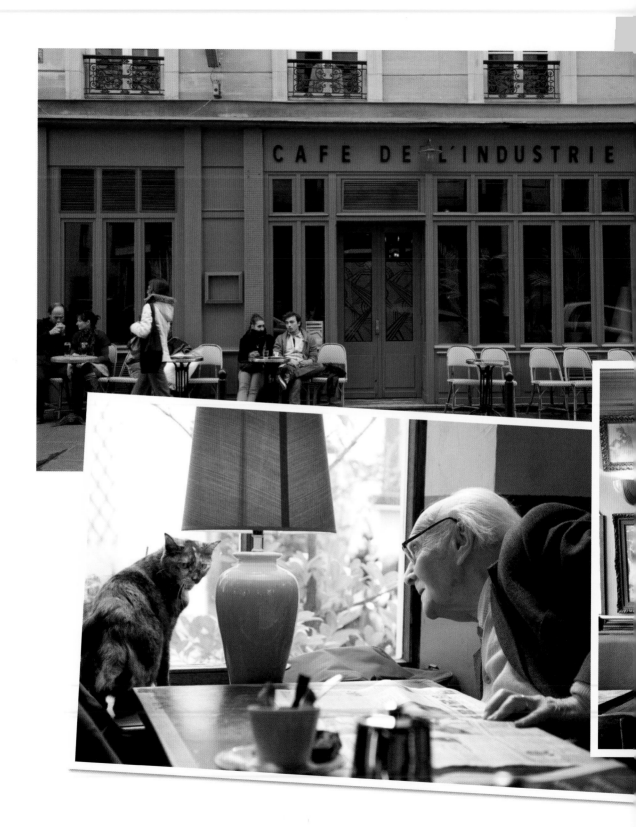

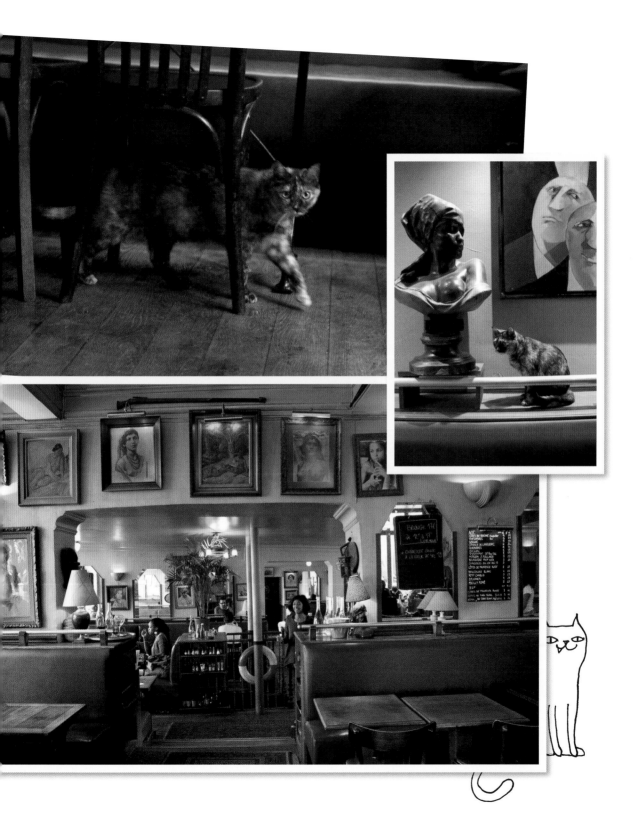

the three locations but mainly stays at the original café, where "she curls up somewhere and pretends she's a statue, then at 11 p.m. she makes an appearance and demands to be petted," says Benoît.

Mimine does get out and about and sometimes goes farther afield, says Benoît, but most locals know her and keep the café informed. "I used to worry about her and try to track her down. People call and say they've seen her on such and such a street."

Just across the vast place de la Bastille in Mimine's neighborhood—which is a hotspot for music lovers, night owls, and political demonstrations—the boulevard Henri-IV borders the Marais with its mansions which were commissioned by the nobility in the seventeenth century. When the boulevard was being built, workers came across a black marble tomb with a statue of a cat on top of it. It was the burial site of Ménine, the beloved cat belonging to the seventeenth-century Duchess of Lesdiguières, Paule de Gondi, who lived in the nonextant Hôtel Lesdiguières.

Mimine's street runs across the wide, tree-lined boulevard Richard-Lenoir, a classic creation by Baron Haussmann, who carried out a massive urban planning reform in Paris under Napoleon III. The boulevard actually covers the Canal Saint Martin, which resurfaces near République. Twice a week, it hosts one of Paris's largest and most bountiful open-air markets. Boulevard Richard-Lenoir is also the fictional home address of commissioner Jules Maigret, the unforgettable pipe-smoking, wine-drinking Paris-based detective created by Belgian author Georges Simenon, who has been incarnated in numerous screen and radio adaptations worldwide, best portrayed, perhaps, by iconic actor Jean Gabin in the 1950s and 1960s. It's easy to imagine Maigret, often described by Simenon when he is having a meal in a neighborhood café, sharing a steak tartar with Mimine, who is particularly partial to the dish.

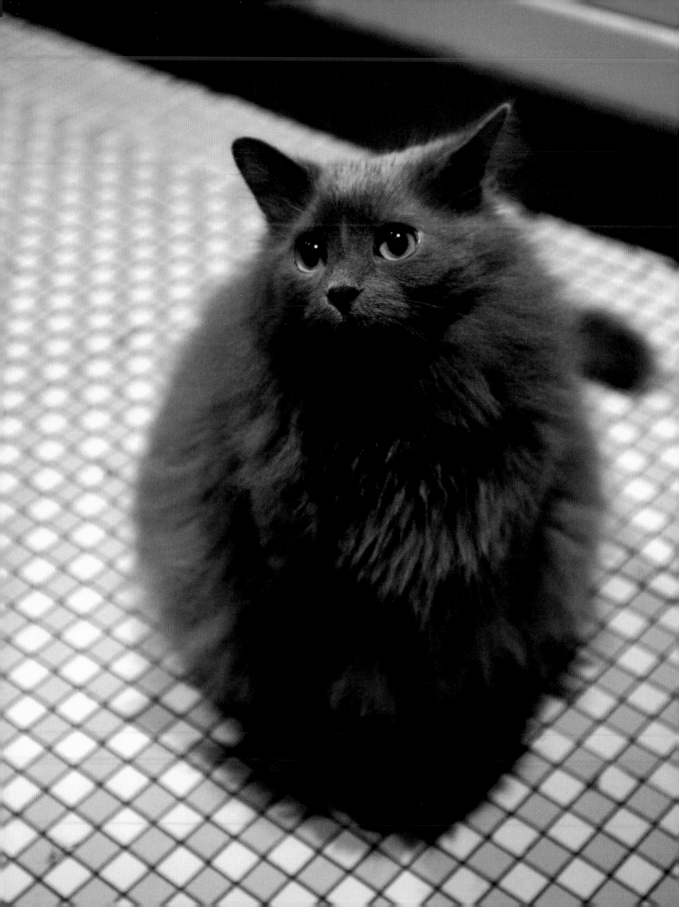

LE CAFÉ ZÉPHYR 12, BOULEVARD MONTMARTRE 75009 PARIS +33 1 47 70 80 14

Swiffer

Honoré de Balzac and Guy de Maupassant wrote about them, Fred Astaire visited them in the movie *Funny Face*, and Yves Montand sang about them. They are Paris's "Grands Boulevards," a series of long, straight roads that replaced ancient fortification walls that had been torn down in the seventeenth century. From the eighteenth century onward, Parisians and also tourists adopted these tree-lined boulevards as *the* place to be seen, whether at the Café de la Paix, Café Anglais, or Café Riche, at the Folies Bergère, or at the largest movie theater in Europe, Le Grand Rex.

Le Café Zéphyr, which opened at the turn of the twentieth century, is located on one of the Grands Boulevards and remains a favorite among locals, despite its close proximity to the internationally popular Musée Grévin, the world's oldest waxworks gallery. Inside, the café floors are covered in traditional mosaic tile; the décor is colonial-style; and in the back, there is a billiard table and a few additional café tables on a raised platform covered in plush red carpeting. Outside, a wide terrace area, enclosed during cool weather, is well suited for people-watching on the busy boulevard Montmartre. Early mornings, a dusky gray cat joins patrons on the terrace before the traffic thickens. Passersby stop to pet him, and he poses for tourists with cameras. Swiffer, named a little unjustly after the household duster, is anything but commonplace. A handsome, green-eyed, long-haired male, with intimations of a pedigreed cat, Swiffer is from the Auvergne region of France, like the owner of the café and most of the staff. Although the café is bustling much of the time, during the early morning, there is a sense of being in someone's home—in the kitchen just behind the bar, the prep cooks chop vegetables and swirl chocolate in a bowl for a cake.

"To be precise, he was born on a farm in the Cantal, which explains why he is so fond of eating," says Michael Nicaudie, the manager, who has worked at Le Zéphyr since 2001.

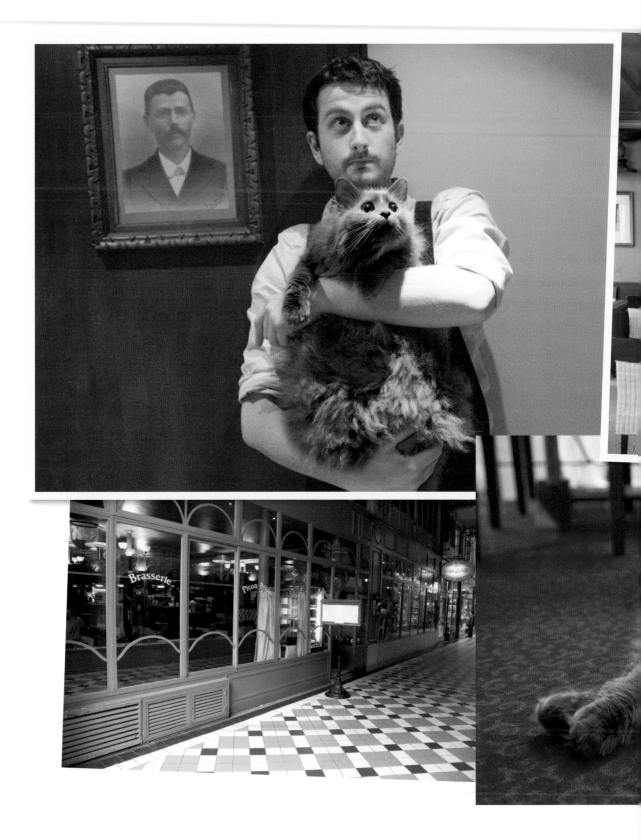

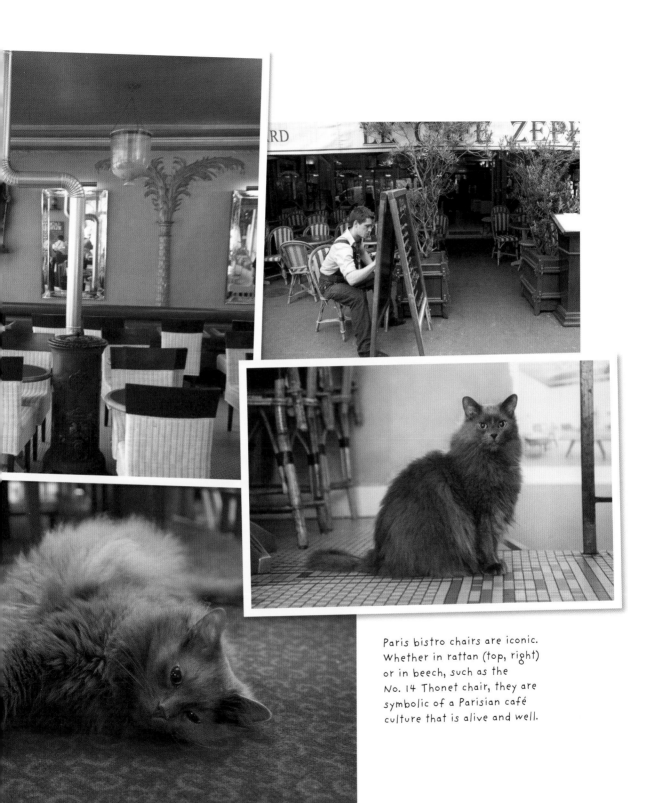

Paris bistro chairs are iconic. Whether in rattan (top, right) or in beech, such as the No. 14 Thonet chair, they are symbolic of a Parisian café culture that is alive and well.

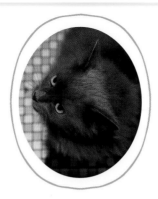

The reason for getting a cat was fairly simple—in Michael's opinion, it is the only deterrent against mice in Parisian cafés and restaurants. As with all the other establishments that acquired a cat for the same reason, once Swiffer arrived in 2008, he quickly became the main attraction.

"He's very popular with clients, and people keep giving him treats, which is why he's a little hefty," adds Michael.

Swiffer is also popular with the staff. Because of his long hair, management decided from the start that he would be brushed twice a week. Everyone, says Michael, takes turns grooming him, and during the session (and otherwise), he will often flop over on to his back for a belly rub.

When the waiters clean and fill the mustard pots, Swiffer lies companionably in a chair at the table. Swiffer also likes to lounge on the soft felt carpet of the billiard table and attempts to sharpen his claws on it when the staff isn't looking.

The side entrance of the café opens directly onto the passage Jouffroy, which dates back to 1847. It is one of the neighborhood's many covered passages that were built in the eighteenth and nineteenth centuries, each with their own particular characteristics. At the time, about sixty passages were built; today, only fifteen or so remain, most of them classified as historic landmarks.

The passage Jouffroy was the first of its kind to be built entirely in iron and glass. The large skylight running along a herringbone-patterned vault covered a dance hall, a puppet theater, and cafés with live music and billiard tables. In 1882, the Musée Grévin—named for Alfred Grévin, a famous caricaturist at the time—opened there, remaining in the same location to this day, renowned not only for its wax figures but also for its extravagant art nouveau décor and wide marble staircase designed by architect Gustave Rives. Swiffer often sits by Le Zéphyr's side entry looking out at the busy passage Jouffroy, just a few doors down from an antique cane shop and a toy store. Although Swiffer is naturally friendly, Le Zéphyr's clients are entertainment enough for him—he rarely crosses the threshold and prefers to stay within the safety of his own café.

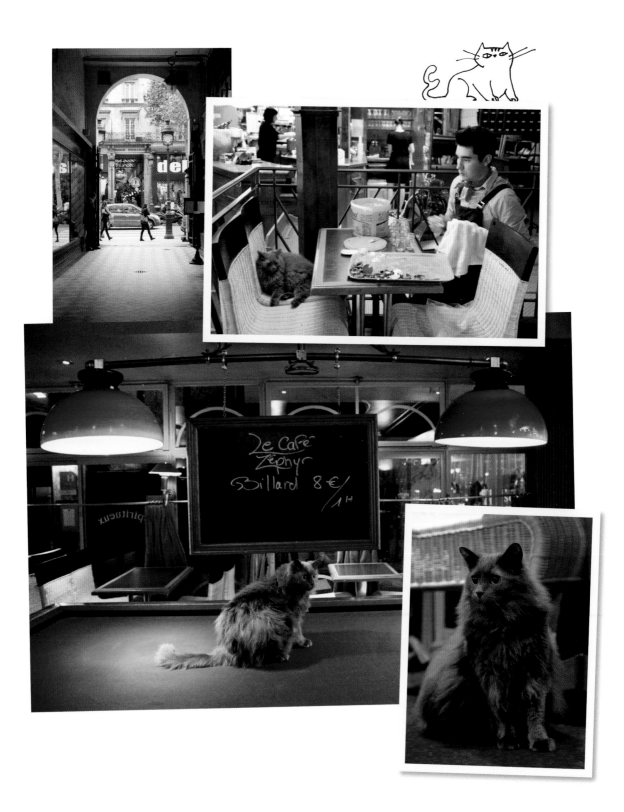

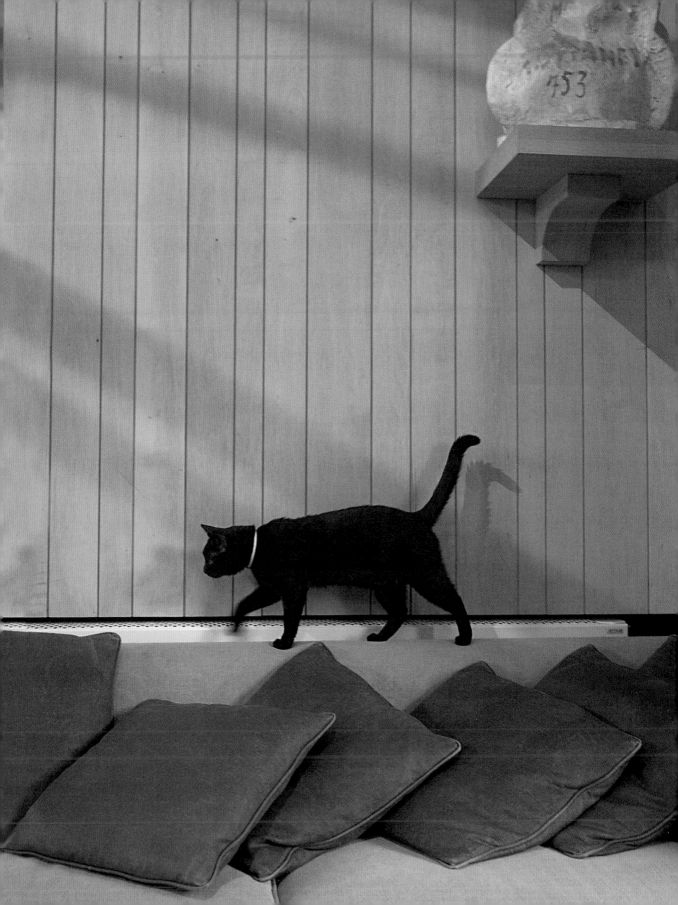

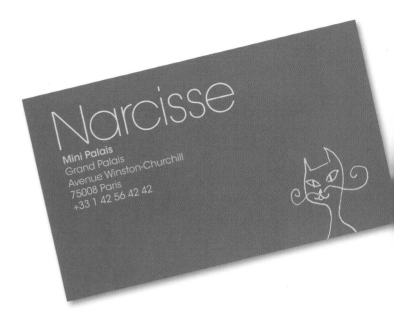

Narcisse

Mini Palais
Grand Palais
Avenue Winston-Churchill
75008 Paris
+33 1 42 56 42 42

During the nineteenth century, the city of Paris regularly organized world's fairs. The Beaux-Arts-style Grand Palais and the adjacent Petit Palais across the street were created for the fair in 1900. The Grand Palais was designed to last, unlike many world's fair structures—including the Eiffel Tower—that were intended to be ephemeral. Four architects were involved in the building, and construction began in 1897. An impressive blend of steel, stone, and glass, the Grand Palais, although classical in its structure, nevertheless shows signs here and there of an art nouveau influence. A few steps away, the Pont Alexandre III is an extravagant celebration of art nouveau with statues of cherubs, nymphs, lions, and winged horses in bronze and gold leaf.

The Mini Palais restaurant opened in the Grand Palais in 2008, under the guidance of three-starred Michelin chef Éric Frechon. At first it was meant to be temporary, but like the Eiffel Tower, it has endured. Its stately entrance with huge bronze doors is to the side of the building, just off the Alexandre III rotunda.

The dining room is immense, with metal beams painted in the Grand Palais's trademark mignonette green highlighting the moldings; huge industrial-style lamps hang from above, diffusing a soft orange light. Ceiling-high arched glass doors lead outside to the terrace lined with mammoth imperial columns and a few elegant statues. Potted palm trees are interspaced among the tables on a beautifully renovated mosaic floor.

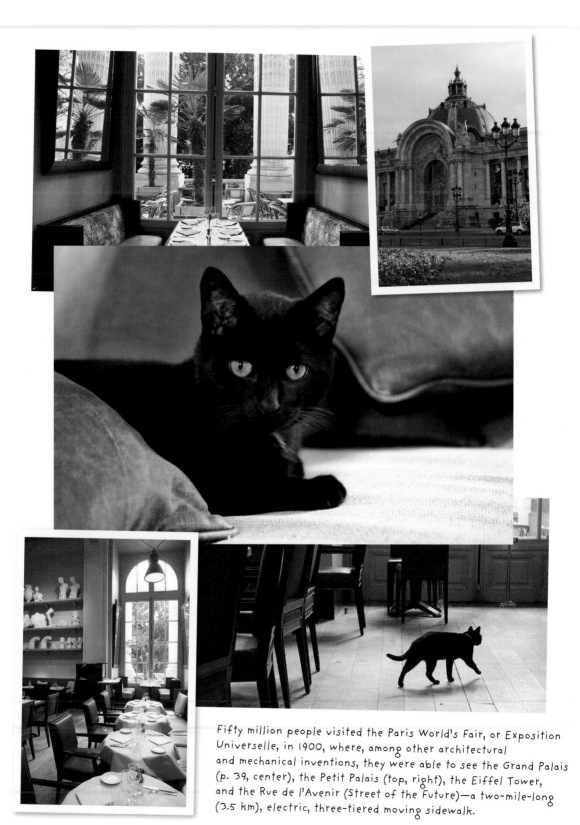

Fifty million people visited the Paris World's Fair, or Exposition Universelle, in 1900, where, among other architectural and mechanical inventions, they were able to see the Grand Palais (p. 39, center), the Petit Palais (top, right), the Eiffel Tower, and the Rue de l'Avenir (Street of the Future)—a two-mile-long (3.5 km), electric, three-tiered moving sidewalk.

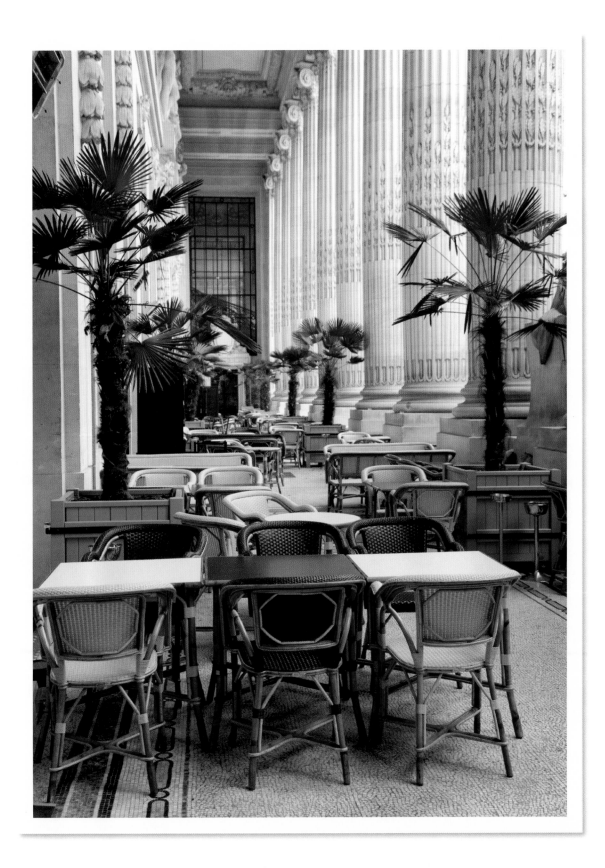

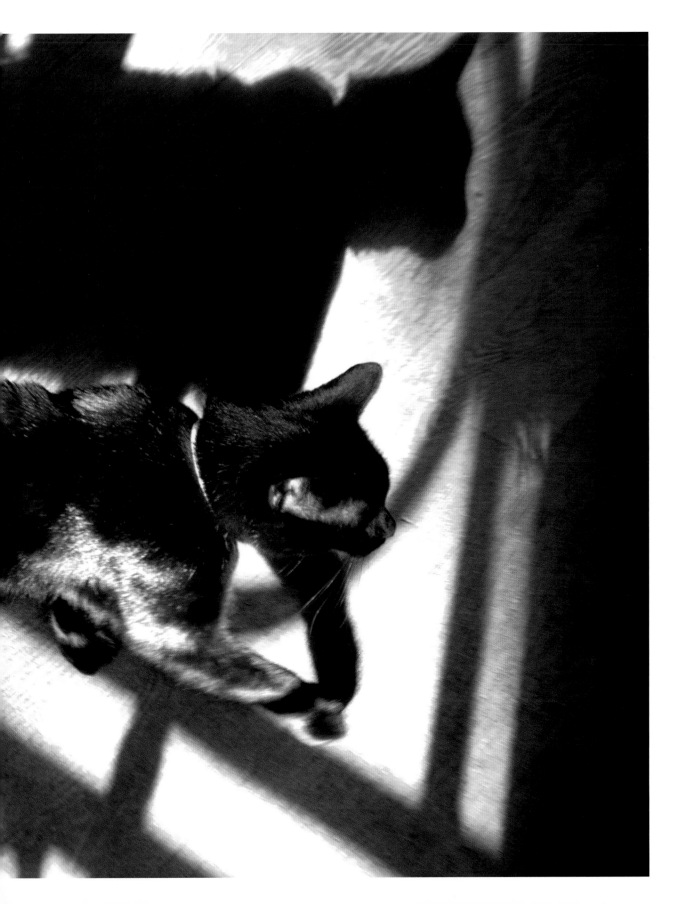

Amid all the grandeur, Narcisse, a small black cat with a tiny patch of white fur under his chin like a bow tie, holds his own, scampering across the floor chasing sunbeams or jumping onto a banquette to play with the edges of a tablecloth. Narcisse will also readily climb onto clients' laps during the lunch and dinner services. Because of the restaurant's proximity to ministries and media outlets, patrons are often politicians or journalists, says Nadia Bisson, the head waitress who has worked at the establishment since it opened. Nadia chose Narcisse for the Mini Palais at an animal shelter in 2011, attracted by his affectionate and sociable nature. It took him three months to adjust to his sizeable domain, she says, but now he is firmly implanted, using the terrace as a self-imposed boundary. The kitchen staff and waiters all interact with Narcisse in varying degrees as they hasten to and fro through the vast dining room, with its plaster molds of museum sculptures on its shelves, and its waiting area with low tables and comfortable taupe-colored sofas with olive-green linen cushions where he likes to nap. The barman tolerates him as long as he doesn't jump on the bar, but Narcisse has better luck with the hostesses, who are happy that he keeps them company at the front door, where he sits on the warm printer next to the computer. Delphine Dubosc says she never liked cats before, but Narcisse has won her over. At the hostesses' station, she demonstrates how he climbs precariously onto a pile of menus in order to drink water out of the tall, black, flower-filled vases.

Through two vertical windows in the waiting area, Narcisse likes to observe the goings-on in the monumental exhibition hall of the Grand Palais where, in 1905, the infamously scandalous Salon d'Automne was held, when Henri Matisse, André Derain, Henri Rousseau, and others exhibited what became known as Fauvist paintings.

"He's just always by our side," says Nadia simply, and as if to prove her point, Narcisse joins the staff as they eat their lunch before the service, seated on leather banquettes under a vast tapestry.

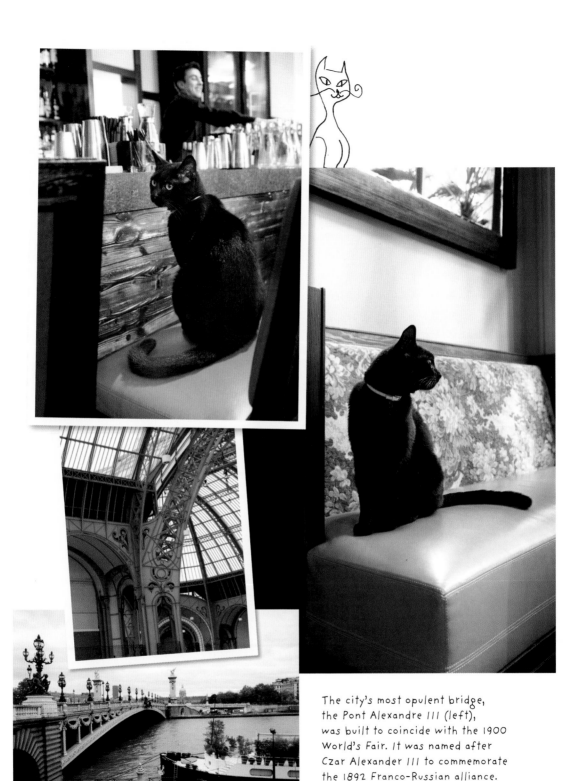

The city's most opulent bridge,
the Pont Alexandre III (left),
was built to coincide with the 1900
World's Fair. It was named after
Czar Alexander III to commemorate
the 1892 Franco-Russian alliance.

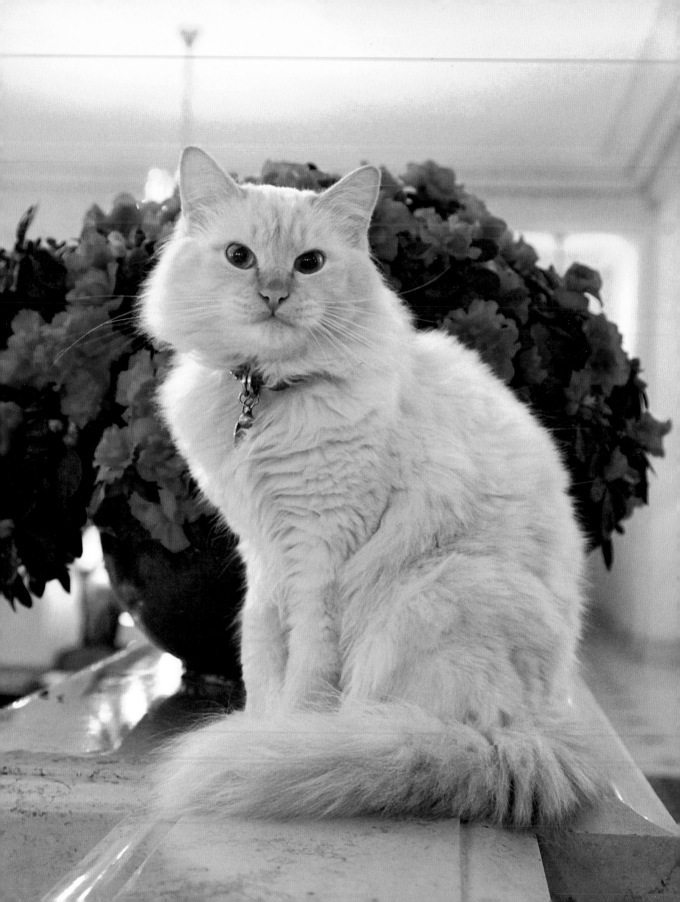

FA-RAON

LE BRISTOL PARIS
112, RUE DU FAUBOURG-SAINT-HONORÉ 75008 PARIS
+33 1 53 43 43 00

When Didier Le Calvez took over as CEO of the celebrated Bristol Hotel in Paris in 2010, he brought years of experience in the luxury industry with him, but the most unexpected innovation was a hotel cat.

That same year, a tiny ball of cream-colored fur with blue eyes arrived in the hotel lobby. The five-star hotel, installed in a mansion that had been owned by nineteenth-century socialite and playboy Count Jules de Castellane, only minutes away from the Elysée Palace, did not settle for just any cat. Fa-raon is a pedigreed Sacred Cat of Burma, also known as a Birman, a breed reputed for its sweet, people-oriented nature. Fa-raon has more than lived up to his reputation: although he is constantly sought out, he is infinitely patient with children and paparazzi alike. Not only has he become an essential member of the Bristol staff, with his own page on its website and numerous photographs on the hotel Facebook page, he has also participated in photo shoots in the hotel for *Harper's Bazaar China* alongside Cate Blanchett and was featured in Japanese documentaries about Paris.

As a kitten, he would curl up in the felt-lined concierge's box where guests left their room keys. As a full-grown cat with points of rust-colored fur, the concierge's desk, with its carved wood paneling softly lit by crystal chandeliers, remains one of Fa-raon's favorite spots. He jabs his paw down the slot of the mailbox or lounges on the dark green Italian marble counter, next to a lit scented candle and a vase filled with roses and peonies, lazily watching clients coming through the revolving doors. Alternately, he will sprawl on the marble floor in the entrance or nibble delicately on the azalea plants placed on low tables in the lobby during the winter season.

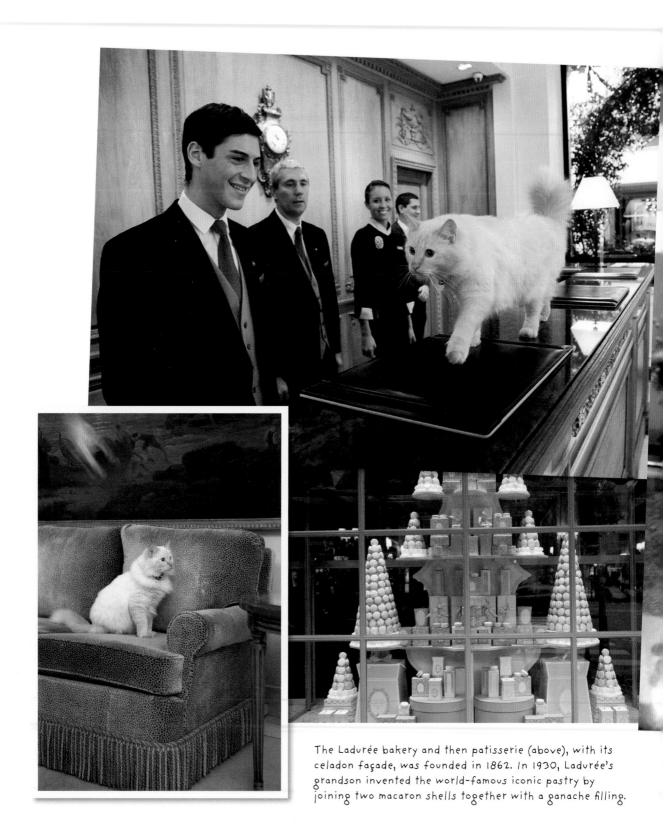

The Ladurée bakery and then patisserie (above), with its celadon façade, was founded in 1862. In 1930, Ladurée's grandson invented the world-famous iconic pastry by joining two macaron shells together with a ganache filling.

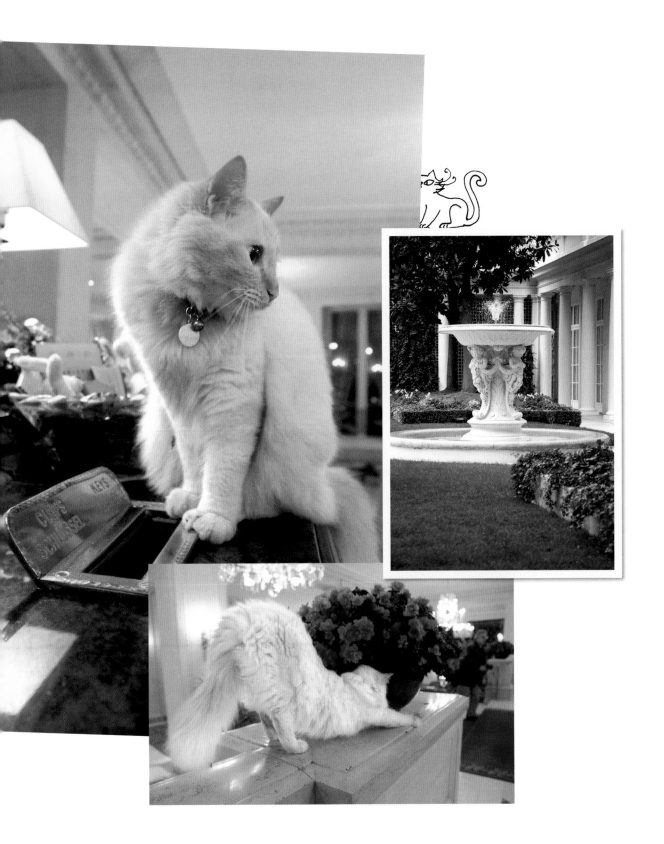

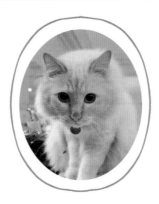

He has several favorite spots for napping: in the business center near the computers (the screensavers feature Fa-raon), where it's particularly warm; or curled up in one of the plush armchairs in the lobby, where cushions are fluffed up regularly by housekeeping; or simply in a corner on the parquet floor of the Castellane banquet hall, decorated with eighteenth-century tapestries, which was the count's private theater in 1835.

Internal hotel email messages buzz around among the staff with missives such as "Don't feed Fa-raon, he has an appointment at the vet's," or "Where's Fa-raon? He has a grooming appointment today."

When Fa-raon is taken to his various engagements outside the hotel, his immediate surroundings are some of Paris's most luxurious. The rue du Faubourg-Saint-Honoré, once a pastoral suburb, developed very quickly once the court left Versailles for Paris in 1715, after the death of Louis XIV. Courtiers and wealthy financiers built luxurious mansions on the street. Adding to the already desirable neighborhood, in 1873 the Elysée Palace, just a few doors down from the Hôtel de Beauvau mansion, already the Ministry of Interior, became the official residence of French presidents. During that same period, the first luxury boutiques appeared, including the saddler Hermès and the dressmaker Jeanne Lanvin. When Hippolyte Jammet, the Bristol Hotel's founder, bought Jules de Castellane's home in 1923, it was the heyday of the Roaring Twenties in Paris where the cultural scene was as vibrant as the arena of fashion and design. Woody Allen appropriately chose to have his main character in the film *Midnight in Paris* stay at the Bristol Hotel—he travels back in time to the 1920s where he runs into, among others, Josephine Baker, Cole Porter, F. Scott and Zelda Fitzgerald, Salvador Dalí, and Man Ray. Fa-raon steered clear of the hubbub during the filming, preferring to remain in the more peaceful lobby and reception area.

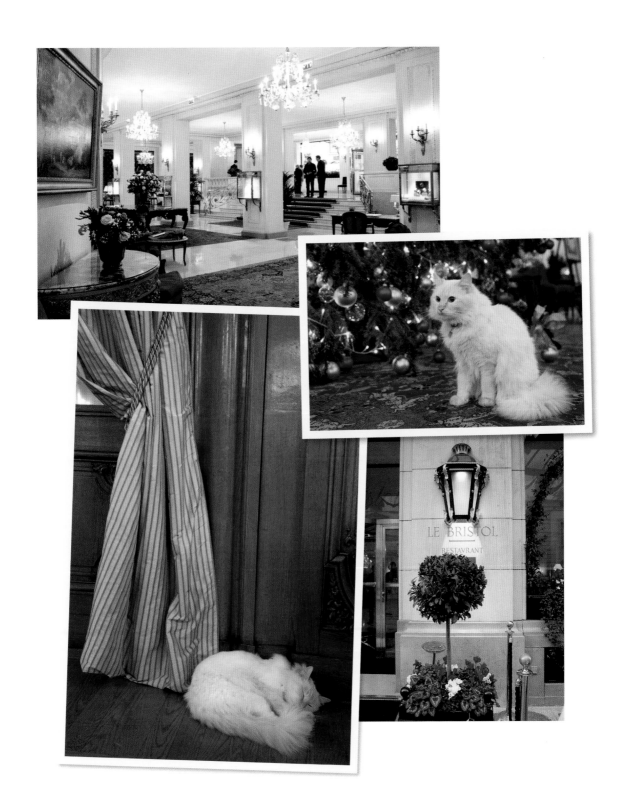

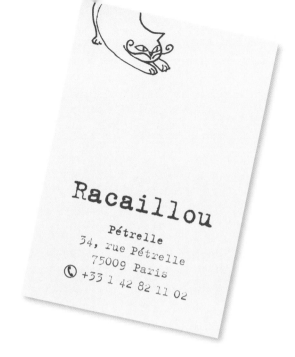

Racaillou

Pétrelle
34, rue Pétrelle
75009 Paris
© +33 1 42 82 11 02

The rue Pétrelle is a quiet street in Paris's ninth arrondissement, just off the rue Rochechouart, which winds its way steeply uphill toward Montmartre. The street and neighborhood are named for Marguerite de Rochechouart de Montpipeau, a seventeenth-century abbess who was also a member of an aristocratic lineage of viscounts of the same name. The other end of the rue Pétrelle runs into the rue Faubourg-Poissonière, part of a well-traveled road taken by fishmongers during the Middle Ages on their way to Les Halles market. When Jean-Luc André found the ground-floor location for his restaurant Pétrelle, in 1994, he says he loved it from the start.

Heavy green-and-orange velvet drapes at the door open onto a space that resembles a whimsical stage setting, the décor somewhere between romantic and surrealistic, "a little bit like life," quips Jean-Luc, clad in red sneakers, with a red-and-white-checkered scarf around his neck. He cooks with a deep connection to the terroir, each week receiving deliveries of seasonal vegetables. The fall brings abundant crates of carrots, turnips, radishes, cabbage, chestnuts, mushrooms of all sorts, and flowers that will decorate the tables—bunches of pink heather tied with string and antique roses. In the midst of a delivery, Racaillou, an elderly, dignified, black-and-white tomcat who sleeps at the restaurant, solemnly greets Fernando, an excitable fox terrier who arrives in the morning. Racaillou's name is derived from the French word for riffraff—*racaille*—which Jean-Luc says he was as a youngster, albeit very *nice* riffraff. There are baskets for both Racaillou and Fernando in the restaurant, discreetly placed away from the

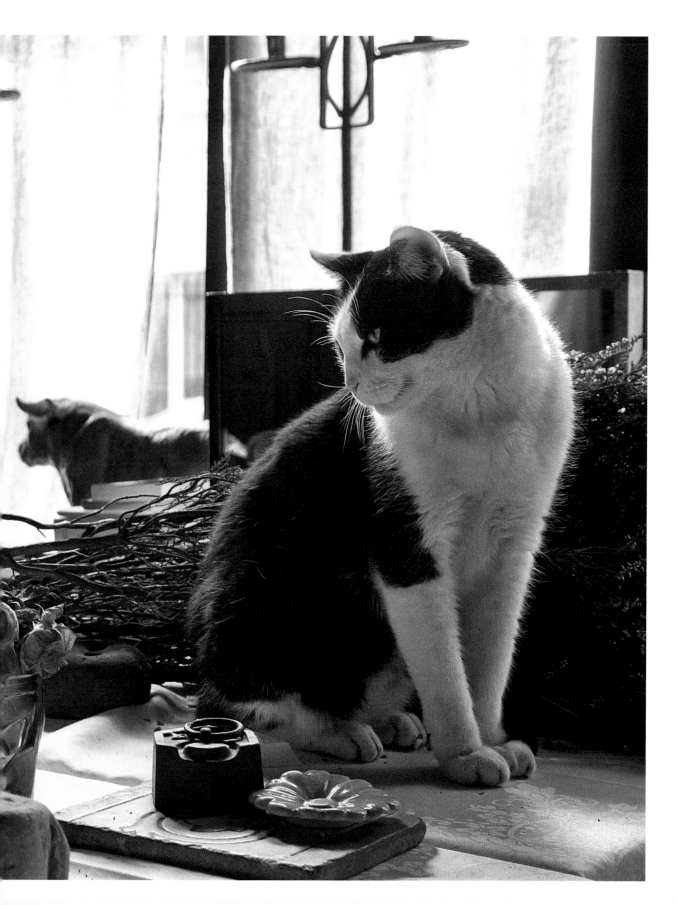

clients, although Racaillou will sit on the chairs that have velvet seat covers, and during the winter, he likes to curl up behind the warm iron stove. Jean-Luc takes both animals to the country regularly but says Racaillou prefers Paris. "He gets depressed in the country. As soon as he gets back to Paris, he starts to fool around again. He likes to be at the restaurant, and he likes being around people."

When Racaillou was younger, says Jean-Luc, he would patrol the street chasing after dogs, even ones as large as German shepherds. He loves children and is visited by a great number of them who walk past the restaurant on their way home from the nearby school.

The neighborhood that is Racaillou's territory was extremely popular during the optimistic and creative period of the Belle Epoque, just preceding World War I, because of the numerous cabarets and dance halls in the area, which included the second incarnation of the celebrated and avant-garde Le Chat Noir cabaret. Thanks to the Belle Epoque's flourishing arts scene, many artists and writers lived in this area, a few streets south of Montmartre.

Inside the restaurant, Racaillou has plenty of nooks and crannies to explore, walking over piles of books on the window sill, inspecting the numerous and varied candles that are lit at night, smelling the enormous bouquet of flowers in a vase near the door, or sniffing at a large white ceramic bowl of homemade meringues tinted violet with the juice of blackberries. For a short while, Racaillou's name was changed to Michelin in jest. Jean-Luc explains: "The Michelin guide people came to Pétrelle for four years in a row. They loved it. But then they told me, there's just one thing: you have to get rid of the cat. I told them to leave. We weren't going to sacrifice the cat for a star."

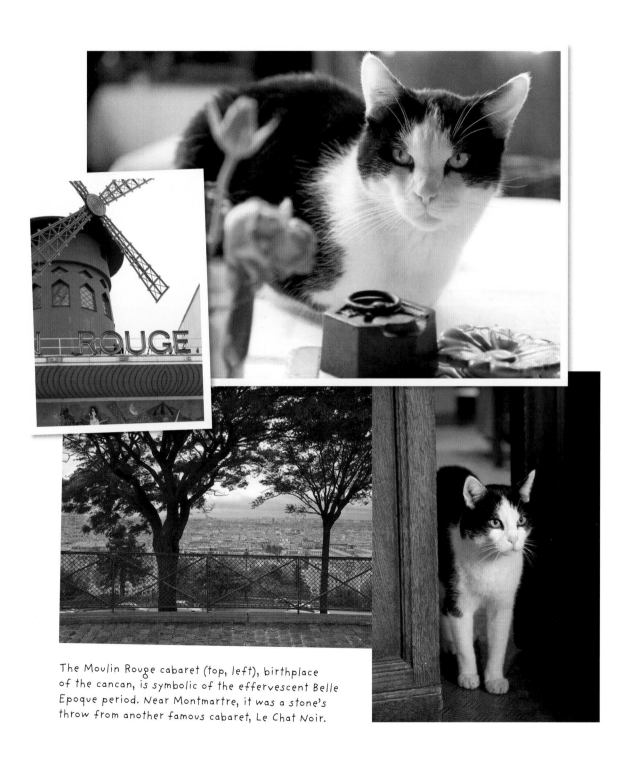

The Moulin Rouge cabaret (top, left), birthplace of the cancan, is symbolic of the effervescent Belle Epoque period. Near Montmartre, it was a stone's throw from another famous cabaret, Le Chat Noir.

The cabaret Au Lapin Agile was a favorite among writers
and painters in the late nineteenth century, including
the Montmartre-born Maurice Utrillo, who painted the pretty
La Maison Rose (The Pink House) just around the corner (right).

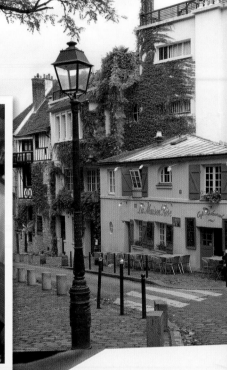

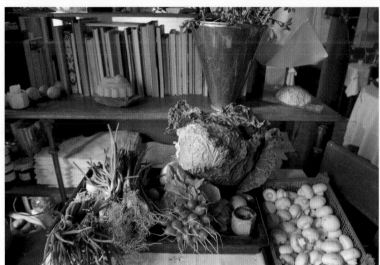

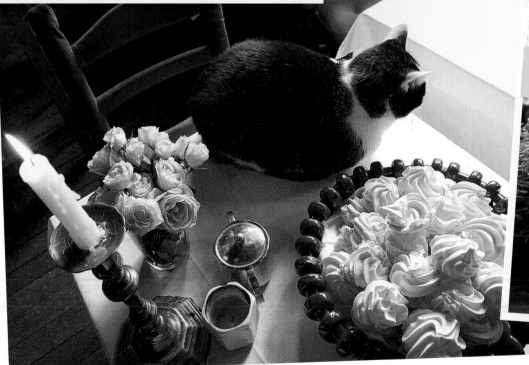

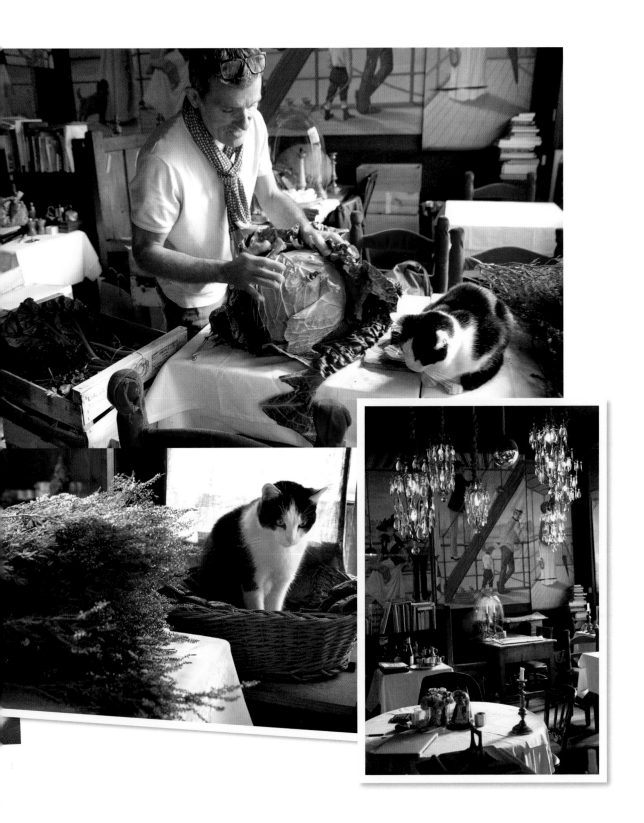

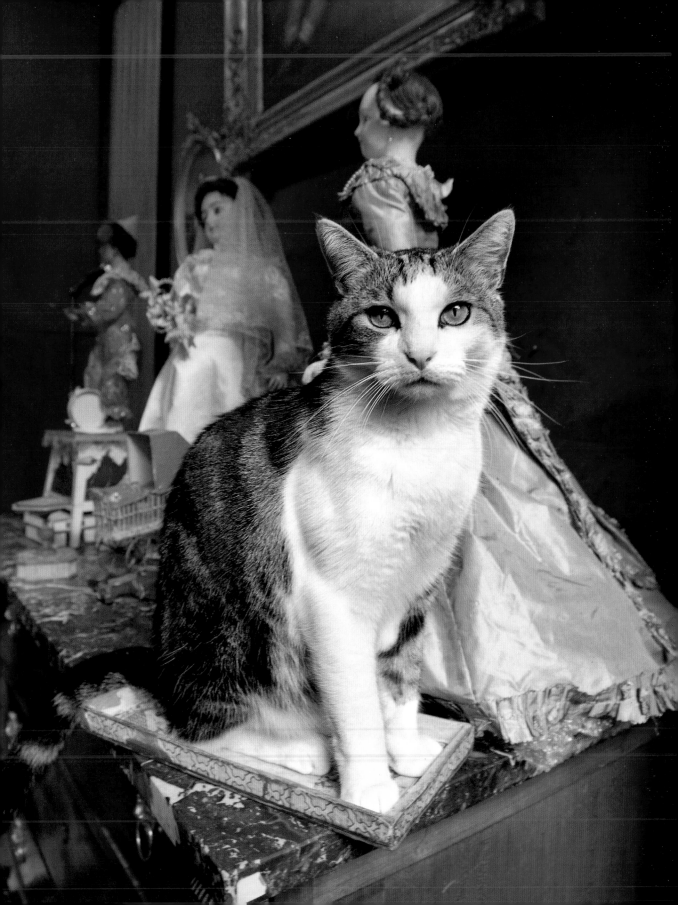

Pilou

La Maison de Poupée
40, rue de Vaugirard
75006 Paris
+33 1 46 33 74 05

L a Maison de Poupée, or The Dollhouse, straddles the corner of the longest street in Paris, rue de Vaugirard, and the rue Servandoni, named after the Italian architect who designed the façade of the nearby Saint-Sulpice church. It is also equidistant from the Senate, housed in the seventeenth-century Luxembourg Palace across the street, and the nineteenth-century Musée du Luxembourg. One of the last shops in Paris to specialize in antique dolls from the eighteenth and nineteenth centuries, it evokes a bygone era, when French dolls were unrivaled in their artistry. But sitting in the wide, storefront window, amidst a retro-chic jumble that includes elegant dolls in papier-mâché, celluloid, and porcelain, is Pilou, very much alive, with tiger stripes on his back and tail, brilliant white fur on his paws and chest, and luminescent green eyes that track the pigeons outside.

Many cats have graced the shop—owner Françoise Vallée says she can't live without them—but Pilou has been the star since 2008, when he was found as a three-week-old kitten in the south of France.

Françoise used to walk past the shop when she was a teenager and would occasionally indulge in small items for her own dolls there. In 1980, she had become an established antiques collector and heard that the shop was for sale; she acquired it that same year, renaming it so that she could include dollhouses. La Maison de Poupée is painted teal

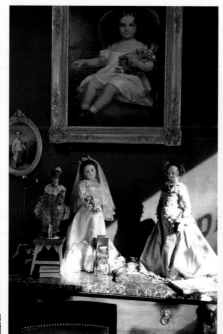

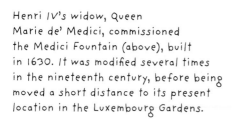

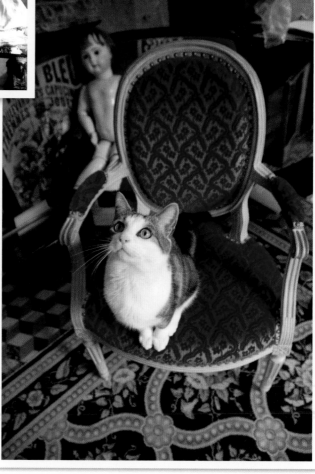

Henri IV's widow, Queen
Marie de' Medici, commissioned
the Medici Fountain (above), built
in 1630. It was modified several times
in the nineteenth century, before being
moved a short distance to its present
location in the Luxembourg Gardens.

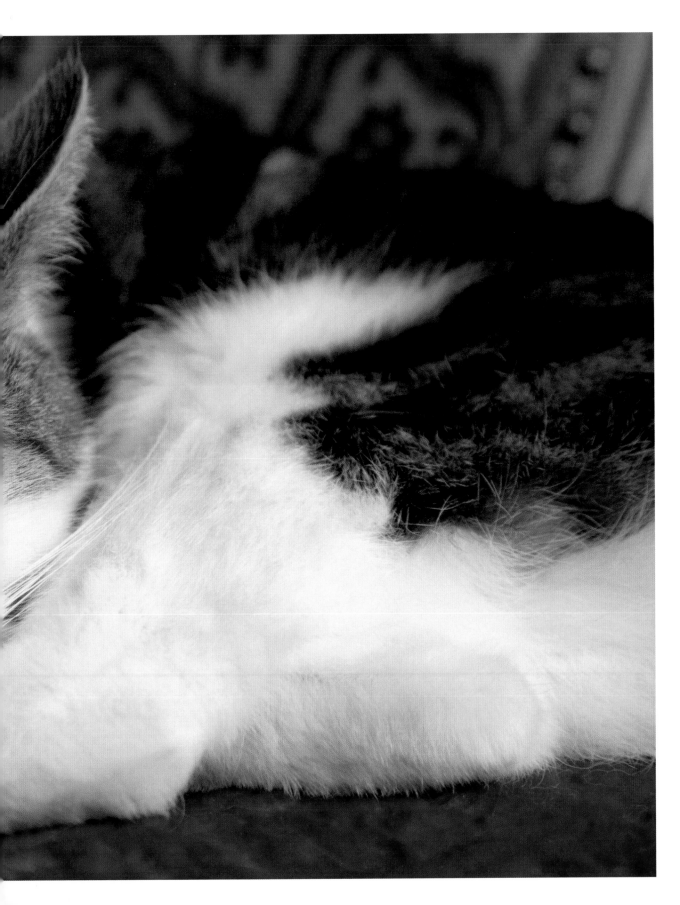

blue on the outside, with limestone walls inside. It specializes in French and German dolls, but also carries dollhouses, accessories for dolls, antique children's furniture, and toys. It is a prodigious discovery for collectors. An enormous doll from 1840, wearing a long, faded green dress with a full skirt, stands on a shelf, her hair arranged in a high bun, while a smaller doll is seated regally on a sedan chair. There are toy kitchen ranges and pots and pans; small bags are filled with tiny dinnerware or replacement Napoleon III–epoch doll's shoes. The shoes are just part of a vast trousseau that belonged to nineteenth-century dolls called "Parisiennes," which emulated the fashionable Parisian women of the time and were unique in the trade for their fashion accessories.

Pilou is particularly passionate about the tiny leather booties, which he loves to fling about on the Escher-style black, white, and gray tiled floor, when he can get hold of them. His preferred throne is a Napoleon III chair for children, perched on a small table from the same era.

"No, no, no, NO," exclaims Françoise as Pilou begins to sharpen his claws on the chair's upholstery.

In general, however, Pilou doesn't wreak much havoc in the shop, except when he tries to empty her writing desk or gets hold of a doll's wig, which Françoise says all her cats have loved unequivocally—hairpieces are trophies for them, similar to mice. They have also enjoyed climbing inside the dollhouses, says Françoise, but only Pilou has proved an art lover; she once saw him sitting on a toy horse, quietly contemplating a landscape painting.

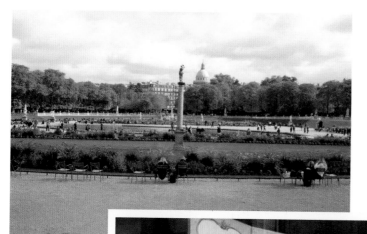

In 1612, Queen Marie de' Medici bought the first parcel of land that was to become the sixty-one-acre (25 ha) public Luxembourg Gardens. They include not only the French Senate, housed in the Luxembourg Palace, but also numerous trees, flowerbeds, fountains, an orangery, a small orchard, and a hothouse containing a collection of tropical orchids.

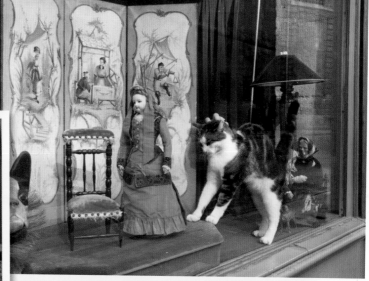

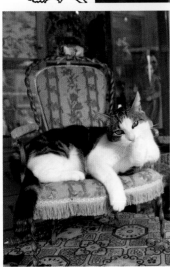

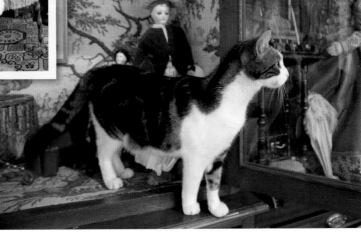

Zwicky

Fleux 39 & 52, rue Sainte-Croix-de-la-Bretonnerie 75004 Paris +33 1 42 78 27 20

The rue Sainte-Croix-de-la-Bretonnerie is one of the oldest streets in the Marais; its name comes from a thirteenth-century convent located there that disappeared during the French Revolution. It was later known for being the street where the chocolate company Menier was founded in 1816.

The Marais, with its wealth of historic relics, has gone through various incarnations throughout history—as marshy farmland in the early Middle Ages, as residence for royalty in the thirteenth century, and then as the area of choice for France's nobility in the seventeenth century. It is epitomized by the place des Vosges, with its high-roofed houses of red brick and stone supported by arcades, and by the numerous mansions such as the Hôtel de Sully or the Hôtel Carnavalet. When the nobility moved out, the Marais became a commercial center before evolving into a working-class area; eventually, many of the buildings were in severe need of renovation. It wasn't until the 1960s, with the support of the writer André Malraux, who was Minister of Cultural Affairs at the time, that the entire sector was protected and rehabilitated. The Marais today is filled with high-end boutiques, galleries, and museums, but traces of a more modest past remain, and Zwicky, an impressively ample cat with tiger stripes and luminous green eyes, is a holdover from that past. Fleux, a quirky and hip concept store that has expanded to four locations on the rue Sainte-Croix-de-la-Bretonnerie, inherited Zwicky from a former haberdashery, Ryckaert, which sold its space to Fleux in 2012. Ryckaert was the oldest shop on the street and the last wholesale haberdashery in Paris. Lucienne Montanari, a longtime Ryckaert employee, found Zwicky and named

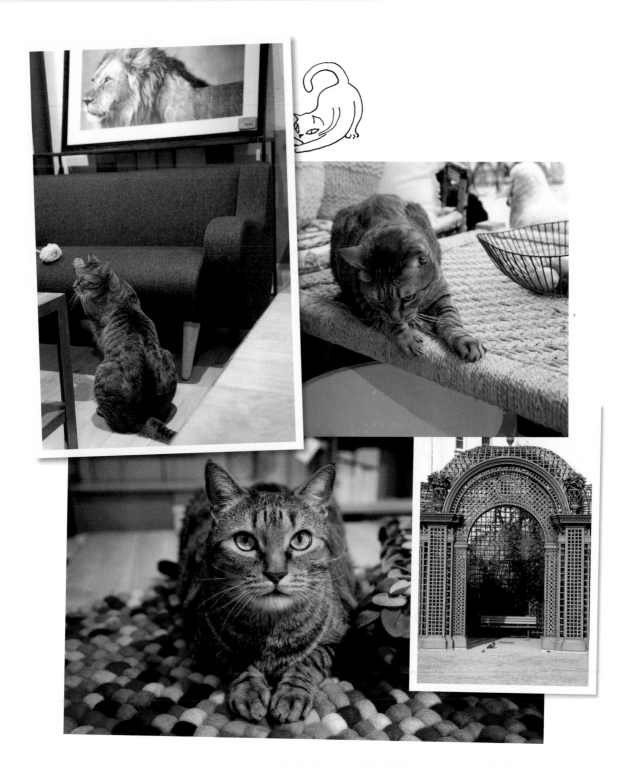

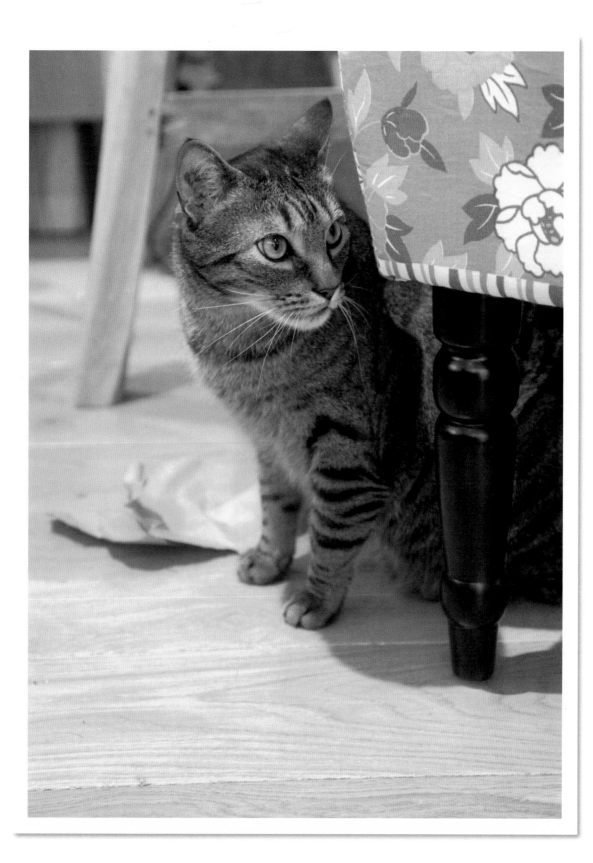

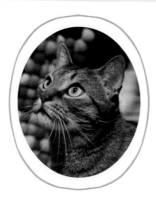

him for a centuries-old Swiss thread company. When Ryckaert closed, Lucienne, in her eighties, was worried about Zwicky's well-being and talked Fleux's owners into adopting him. Lucienne says she visits Zwicky nearly every day, and when she leaves, "he accompanies me to the door."

The shops are veritable treasure troves, filled with singular and wondrous design objects for the home—from chic anthracite-gray sofas to furry, patchwork, or embroidered cushions, or brightly colored nutcrackers in the shape of robots. Zwicky tends to stay in one of the shops in the back of a courtyard, where his former home was located. He reigns from a sky-blue armchair with a $1,000 (€800) price tag on it, which has become "his" chair. "We can't possibly sell it now," quips Gaétan Aucher, one of the owners.

When he first settled into his new home at Fleux, Zwicky had some weight problems because "twenty different people were feeding him," explains Cécile Dromard, one of the managers, who put him on a diet and hung up a chart on which employees keep track of when Zwicky has been fed. Although he is still thickset, Zwicky has no problem leaping into the large cartons that are delivered each day or skidding across the floor to chase a ball of crumpled wrapping paper. Cécile says that not only is he crazy about boxes, but he also loves coffee and will poke his nose into an unattended cup and begin lapping.

"People often mistake him for a stuffed animal," comments Cécile. "He climbs onto the display shelf with the animal cushions and you can't tell the difference."

Zwicky keeps the employees company all day, assisting with the cardboard boxes or unrolling wrapping paper. When they leave in the evening, he usually sits in the shop window to watch passersby.

"Clients often tell us the shop is fabulous, but then they say that the best thing about it is the cat," says Gaétan.

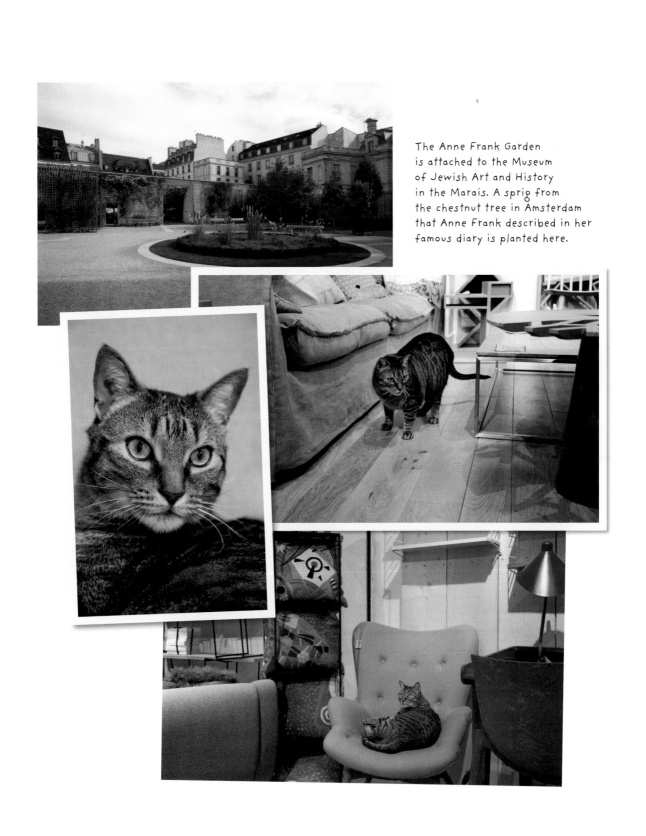

The Anne Frank Garden
is attached to the Museum
of Jewish Art and History
in the Marais. A sprig from
the chestnut tree in Amsterdam
that Anne Frank described in her
famous diary is planted here.

Marie la Varande's sculpture studio on a quiet street in Paris's northern Batignolles neighborhood is a cat's paradise. Classical music plays softly, there are multitudinous stools of varying heights to jump on, toys made from wine corks attached to strings are placed in strategic locations, and a large rectangular sink is perfect for sitting in and lapping at the tap.

Tanned, swathed in scarves, and wearing work boots, Marie la Varande is elegantly disheveled. This sculptor opened her studio in 2004 and brought a kitten from Brittany here four years later: Boule, a tiger-striped female with a round face and posture reminiscent of an Abyssinian's. Baba, also striped but with a white chest and paws, joined her soon after. Both cats often sit in the window, drawing much attention from pedestrians. They have the run of the studio, which is filled with students all day long, for the most part a well-heeled, older crowd. A burly former French navy admiral sculpting a large piece of wood tells us that cats like him, as Boule walks in front of his sculpture, adding as an afterthought, "I like cats as well."

Bookshelves are packed tightly with art books; coffee, tea, and chocolates are laid out on a low table. An antique black telephone hangs on the wall next to a shiny espresso machine. Bottles of wine are stacked in a corner next to jars of pigment.

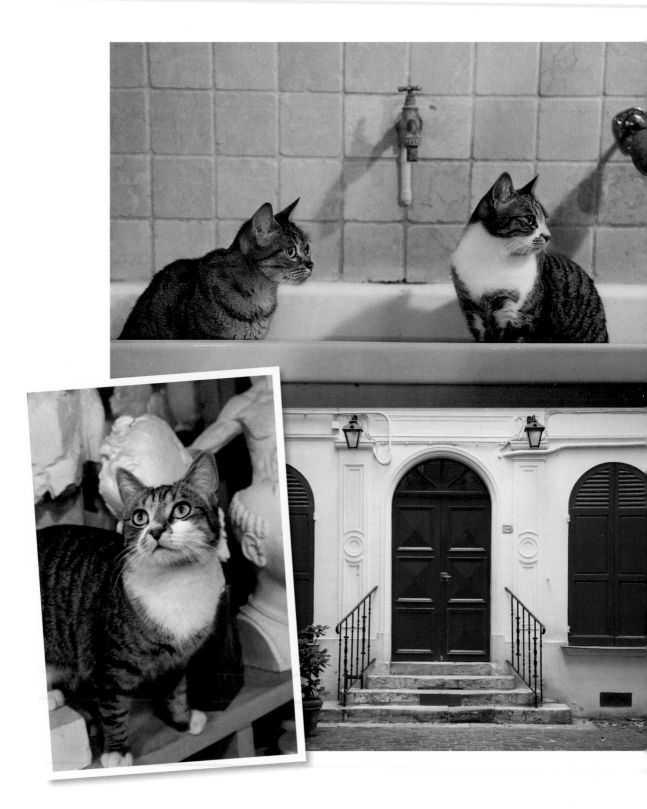

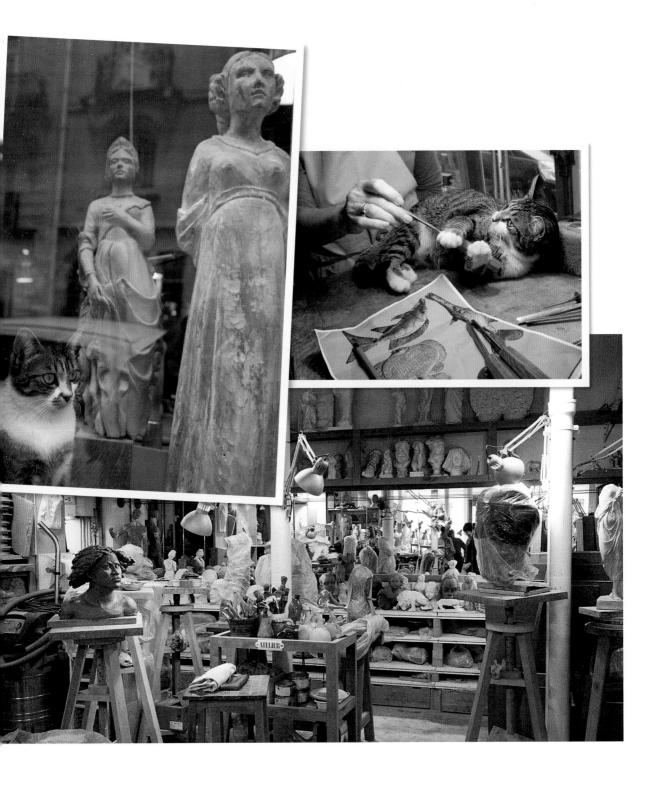

The studio continues a tradition that began in this area—which only became part of Paris in 1860—during the nineteenth century when the painter Édouard Manet created the Batignolles School, known as the "Groupe des Batignolles" in 1863. That same year, Manet's oil painting *Luncheon on the Grass* had scandalized the Parisian art world as much for its depiction of a naked woman sitting with two fully clothed men as for its innovative lack of transition between light and dark elements in the painting. Congregating in the Café Guerbois, not far from Manet's studio, impressionist painters such as Frédéric Bazille, Claude Monet, Pierre-Auguste Renoir, and Alfred Sisley, joined occasionally by Paul Cézanne and Camille Pissarro, would discuss new ways of depicting modern life. Led by Manet, the artists struggled to have their emerging avant-garde work accepted by the conservative art establishment of the time. The writer and journalist Émile Zola often joined them. He had intentionally abandoned the Latin Quarter to move to the Batignolles in 1866 in order to be closer to the group of experimental painters; he described the Café Guerbois as the cradle of a revolution.

In Marie's studio, sculptures can be made in wood or clay, and there are also classes taught in charcoal and pastel drawing. Occasionally, there are live models, and Baba and Boule will sometimes settle against their legs, sinking into the cushions behind the models. When they're not sleeping on the radiators, the cats frolic around the students, playing with their apron strings or pawing at the various tools on the workspaces. Baba often lies under a studio lamp and pulls it closer to her with her paw so that the heat is more intense.

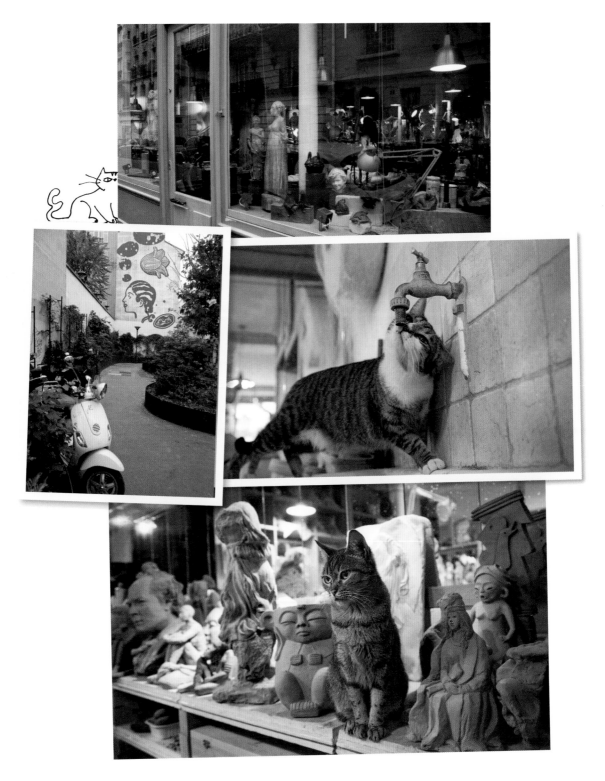

LE ROSTAND
6, place Edmond-Rostand
75006 Paris
+33 1 43 54 61 58

Directly across from one of Paris's loveliest gardens, the Luxembourg, and a short walk from the Sorbonne University and the Panthéon, Le Rostand café and nearby square are named after the neo-romantic poet and playwright Edmond Rostand.

The large café terrace, enclosed during the winter, is bordered with potted palm and olive trees, the corner section perfectly angled to receive the morning sun. The clientele is a mix of university professors, publishers, writers, and tourists, all greeted by Le Rostand's cat-in-residence, the charming young Roxane, who is predominantly white, with a striped brown and gray tail. Her predecessor Cyrano—named in honor of the nineteenth-century writer's best-known play (despite being female)—had been the café's cat for many years, until she disappeared one summer. Roxane, named after Cyrano's love interest in the play, was auspiciously found soon after, hiding on the café terrace, terrified. A kitten, she weighed a mere pound (480 grams) and was injured. Manager Jean-Pierre Berthe, who has run Le Rostand since 1998, nursed her back to health. He says that, for a long time, she would only sleep safely hidden from sight under the rust-colored marble countertop of the wooden bar. Her food bowls are still neatly aligned on the wooden platform below the cash register there, even though she

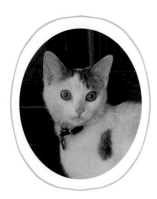

now sleeps on the more comfortable leather banquettes. Although he asserts that he never gives her leftovers, Jean-Pierre admits that Roxane has a fondness for ham, chicken, and raw meat, but to his dismay, she doesn't like fish at all—he has tried both raw and cooked.

Most mornings, while the clean-shaven Jean-Pierre reads *Le Parisien* and chats with the headwaiter, Roxane sits primly on one of the café tables in a stream of sunlight looking out toward the same trees in the Luxembourg Gardens that Victor Hugo described over one hundred and fifty years ago. Amid the clatter of cups and the steaming espresso machine, Roxane shows little of her previous timidity.

"She is incredibly sociable," Jean-Pierre comments, adding that he has always loved cats, but his wife doesn't want one at home "because of the claws and fur. So I have one here."

Roxane is still cautious around the main café entrance, whose swinging doors lead to the terrace and street, but Jean-Pierre is confident that she will get used to it and slowly expand her territory as Cyrano did—first to the terrace (heated in the winter) and then to the Luxembourg Gardens. When Roxane has finished making her morning rounds of the regular clients, she weaves her way across the mosaic-tiled floor, between the legs of the wicker café chairs toward the back of the café where oriental-style paintings, antique photographs of palm groves, and stucco sculptures of palm trees adorn the walls. She likes to nap under the banquettes, soon to be occupied by lunch patrons.

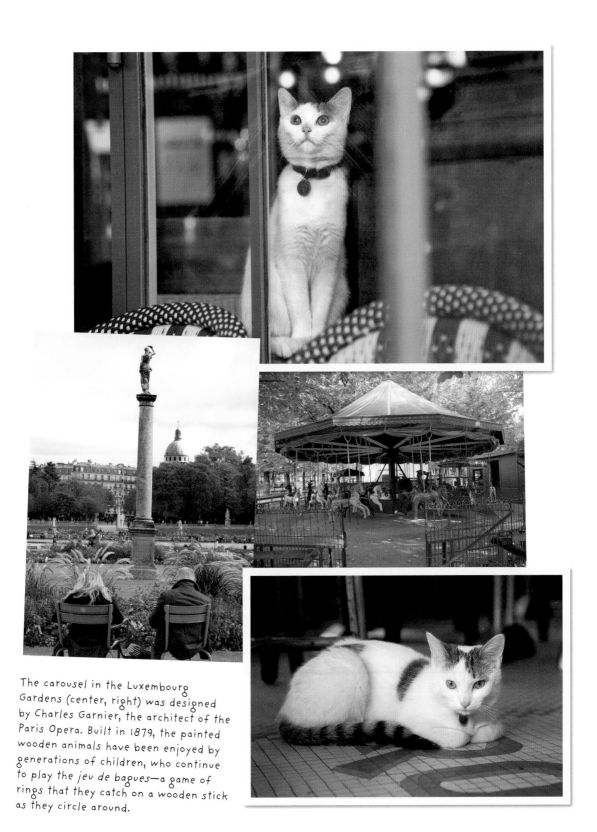

The carousel in the Luxembourg Gardens (center, right) was designed by Charles Garnier, the architect of the Paris Opera. Built in 1879, the painted wooden animals have been enjoyed by generations of children, who continue to play the *jeu de bagues*—a game of rings that they catch on a wooden stick as they circle around.

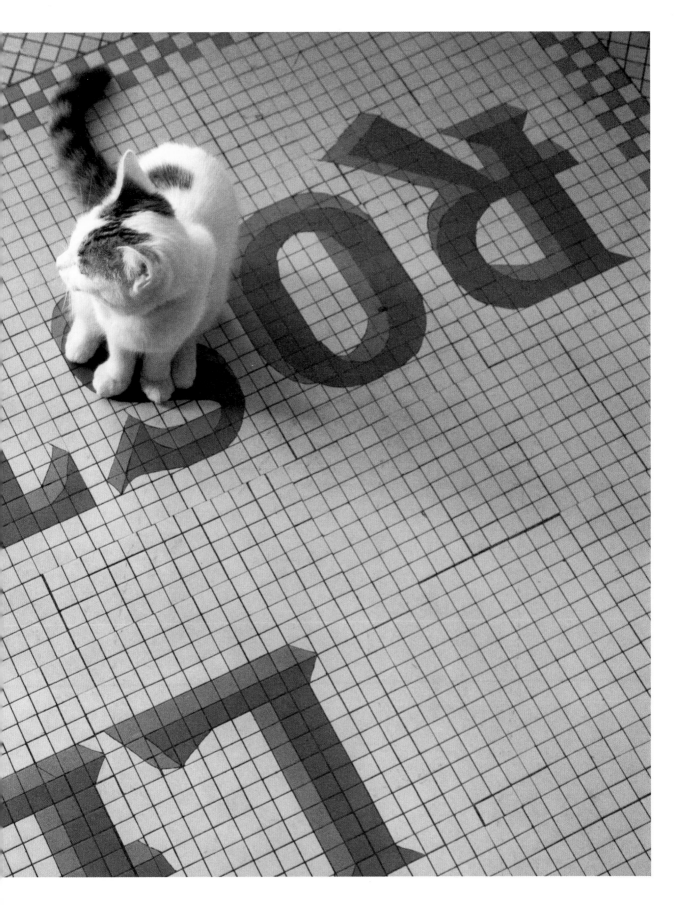

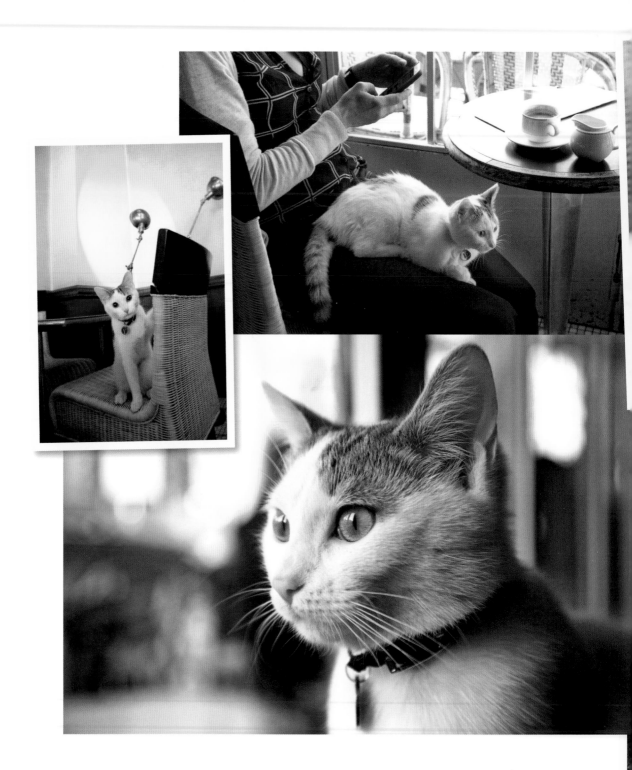

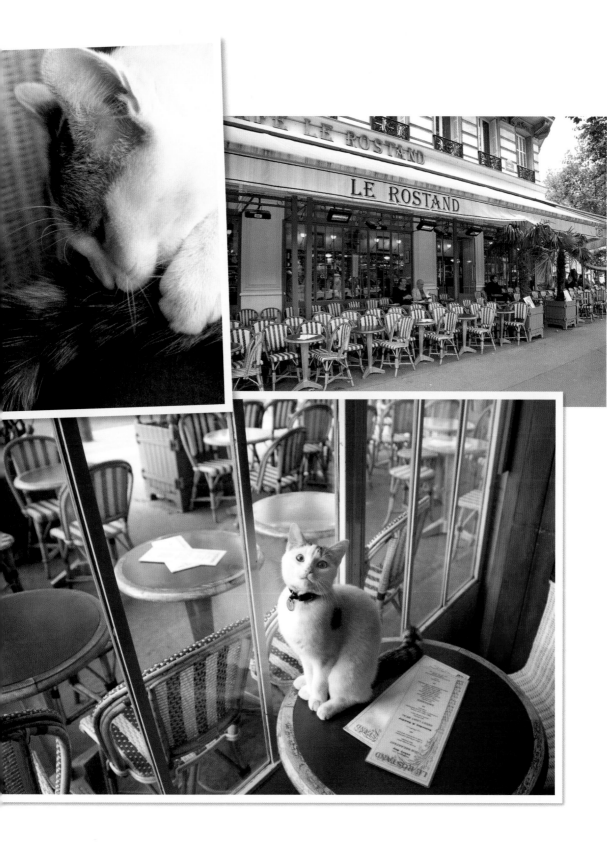

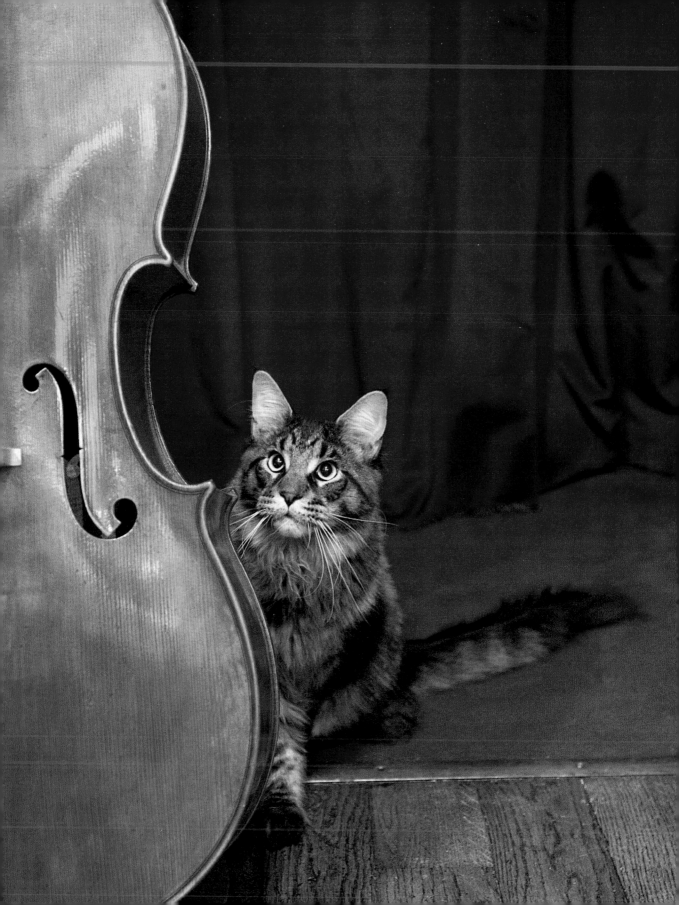

The rue de Rome has been synonymous with luthiers, or stringed instrument makers, from the early twentieth century onward, when many transferred their workshops to the area to follow the Paris conservatory of music and dance (founded in 1795), which had moved to the nearby rue de Madrid. The conservatory later moved again, but the luthiers remained. The rue de Rome is also conveniently close to the Opéra Garnier.

The storefront window of Le Canu-Millant is decorated with yellowed sheet music and a model of a giant violin bow in front a red velvet curtain. But what makes passersby stop short in their tracks, music professionals or not, is the vision of a majestic, long-haired, tiger-striped feline stretched out in the window: Helypse, the shop's Maine coon. Born in 2013, he is still a kitten, but as a full-grown cat, Helypse will weigh about twenty-six pounds (twelve kilos). He is already larger than the shop's cream-colored dachshund, Chester, with whom he frolics and wrestles on the solid oak, waxed parquet floor.

Loïc Le Canu and his wife Verena, both luthiers, took over the shop in 1989 from the highly respected Bernard Millant, who had opened it in 1934. Millant is a master luthier from a family of luthiers and bow makers going back one hundred and fifty years. Now well into his eighties, he still works in the atelier two afternoons a week. Loïc and Verena have handed over the business to their son, Nicolas, who has been working with his father since 2000, but they still come to the shop three days a week, and Loïc brushes Helypse while he drinks his coffee. Helypse is Nicolas's cat, and he carries him to work every day, draped over his shoulders. His neighborhood is an interesting one, just up the hill from the busy Gare Saint-Lazare, which was France's first train station, built in 1837 and moved to its current location several years later. The station's classical façades are designed in stone; the train platforms are covered with a glass canopy; and a glass-roofed gallery links the main concourse with other buildings. Featured in paintings by the impressionists, who lived close by, the Gare Saint-Lazare was also unforgettably documented by Henri Cartier-Bresson's 1932 photograph of a man leaping over

Boulevard des Batignolles delineates the Batignolles neighborhood of Paris. The pedestrian walkway down its center is lined with trees (below), some of which are several hundred years old.

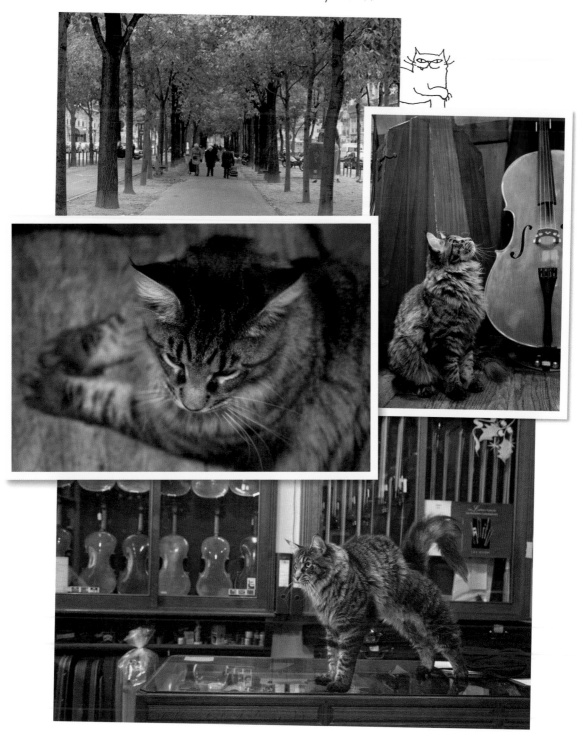

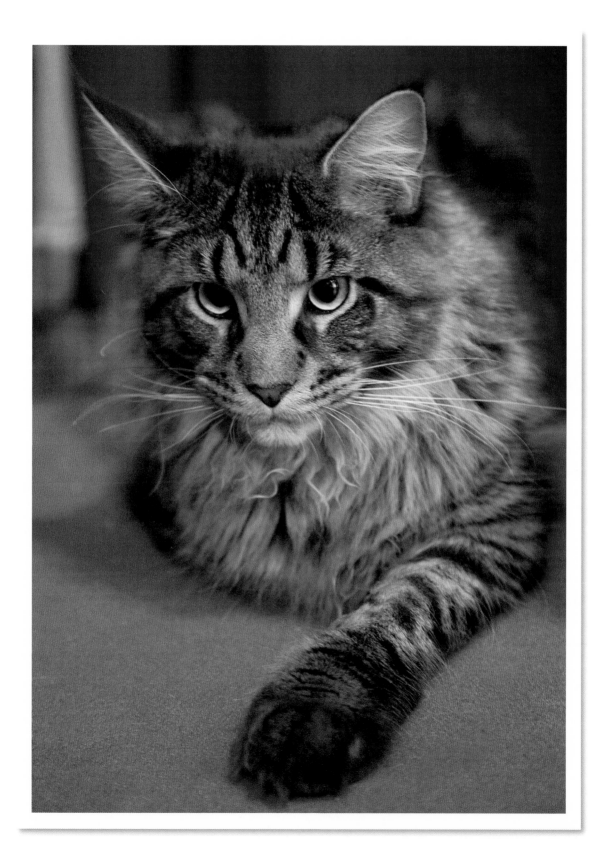

a puddle behind the station. Helypse's street, the rue de Rome, is like many of the streets in the immediate area, named after a city on the European continent—Vienna, Madrid, London—all leading off a square called place de l'Europe, which was built over a viaduct in the nineteenth century.

Inside the shop, photographs of famous violinists and patrons, from French to Russian, line a portion of the wall. There is a glass case on the opposite side of the room containing some thirty violins; the cellos are arranged on another wall. The Le Canu family has close to three or four hundred violins in the shop and rents out about 1,200 instruments a year. The violins are largely French, made in Mirecourt, a village in the Lorraine, where the primary industries are stringed instruments and lace making. In the sixteenth century, the Dukes of Lorraine introduced Italian master luthiers to the village where violin making subsequently became Mirecourt's raison d'être and remains so to this day.

The Le Canu workshop is at the back of a narrow corridor behind the shop's front room. The office space is decorated with a framed photograph of several generations of the Millant family of luthiers, a nineteenth-century safe that Loïc had restored, and a Napoleon III–epoch sofa. In the workshop, bunches of black, white, and beige horsehair used for bows are attached to hooks above food and water bowls for Helypse and Chester; violins hang from the ceiling above, and tools line the walls. Loïc's specialty is bow making, and Helypse's favorite toy is a tuft of bow hair that he chases, skittering about on the parquet. But as a kitten, he was also trained to behave, a necessity because, explains Loïc, "we work with valuable objects."

"Paris is an epicenter for many musicians passing through on the concert circuit," says Loïc. "Musicians are also quite fetishistic about their bows; I have one who stops in Paris to come to the shop on his way to Brazil to have his bows checked."

Most customers love Helypse, says Nicolas. Musicians may be fetishistic; they are also superstitious, he adds. Once, a quartet called Ellypse came into the shop, and following their visit they won a prize. "They were sure that Helypse had brought them good luck."

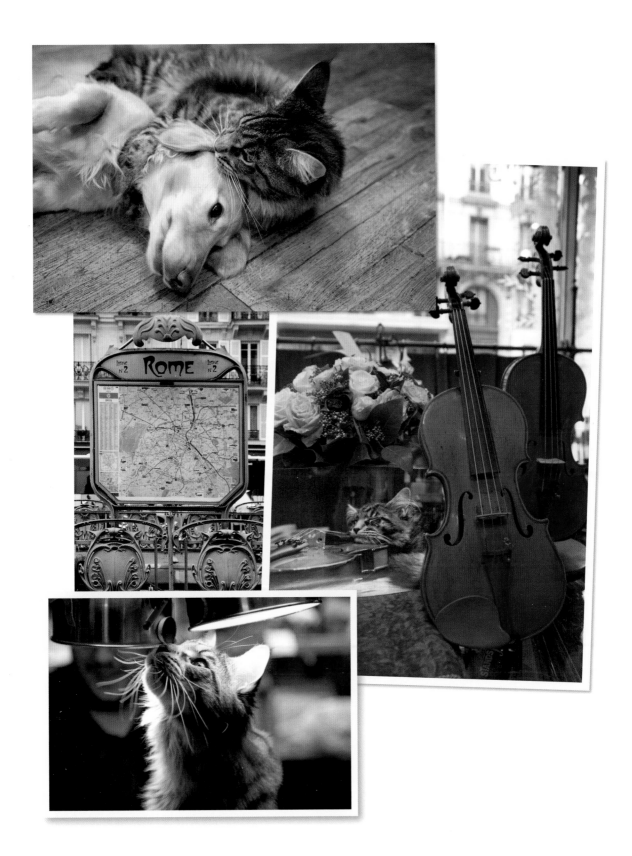

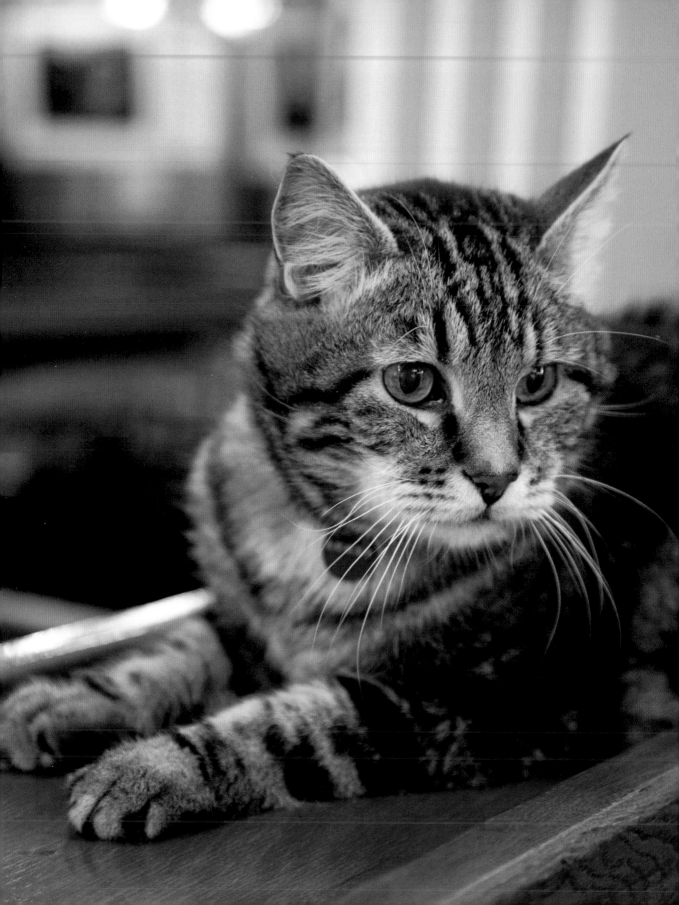

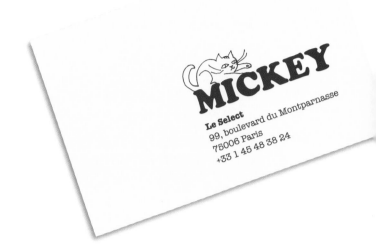

Le Select is one of the best-known brasseries in Montparnasse. With wicker furniture on the terrace and wooden tables with leather banquettes in the front and back rooms, the timeless Le Select opened in 1923 and was a favorite among an artistic crowd that included Picasso, Jean Cocteau, Henry Miller, and Ernest Hemingway. Known as a "Bar Américain" because it served American-style cocktails and had bar stools, it continues to be popular among locals and tourists alike. Artists and writers still spend afternoons nursing cups of coffee in the back room, and regulars gather around the bar conversing with long-time staff throughout the day.

Mickey, Le Select's former cat, was unquestionably contemporary Paris's most famous feline, on an equal footing with the establishment's illustrious and bohemian clientele. Mickey held court like royalty. Mornings found him stretched out on the wooden bar under a gold-tinted photo portrait of himself, taken by René Laguillemie, a self-proclaimed viscount. His afternoons were spent on a banquette in the back room, and his nights on the cashier's desk.

Mickey arrived at Le Select as a young cat, having migrated from the café next door, where he was known as Oscar. A veteran Le Select waiter promptly renamed the new arrival, calling him Mickey, although no one quite knows why. Michel Plégat, Le Select's owner, initially tried to shoo him away in vain. "We didn't know anything about cats at the time," recalls Frédéric Plégat, Michel's son and now one of the managers. But he soon proved useful; during his youth, Mickey was an excellent mouser and would often patrol the terrace.

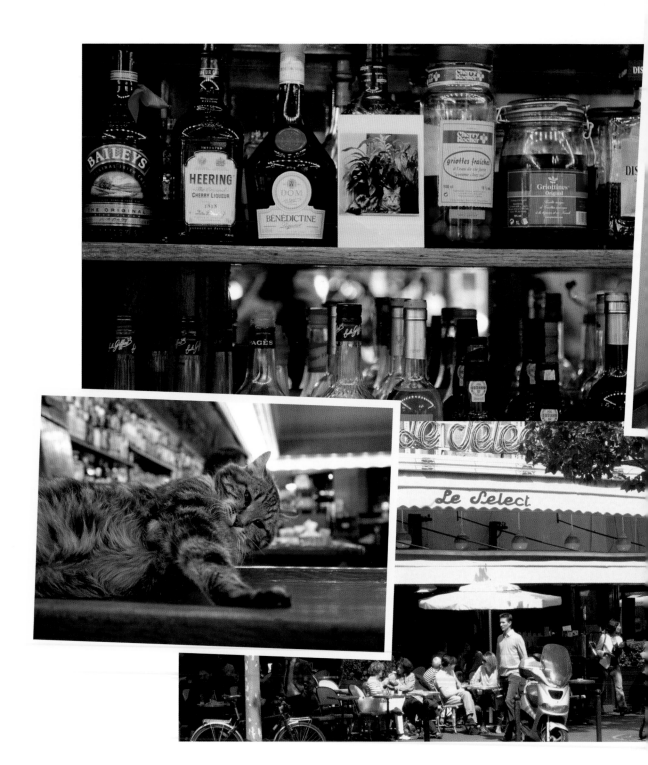

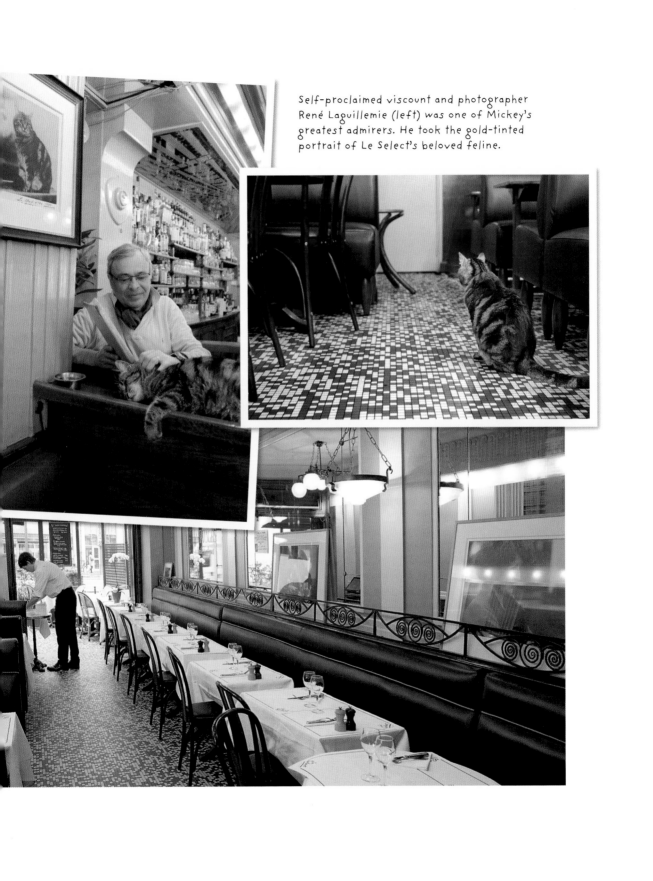

Self-proclaimed viscount and photographer René Laguillemie (left) was one of Mickey's greatest admirers. He took the gold-tinted portrait of Le Select's beloved feline.

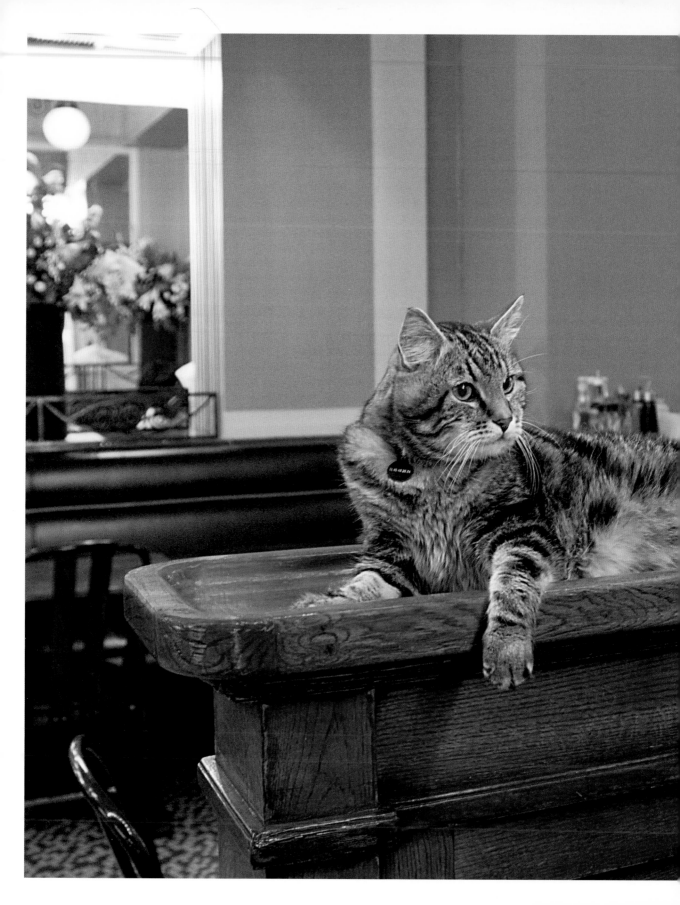

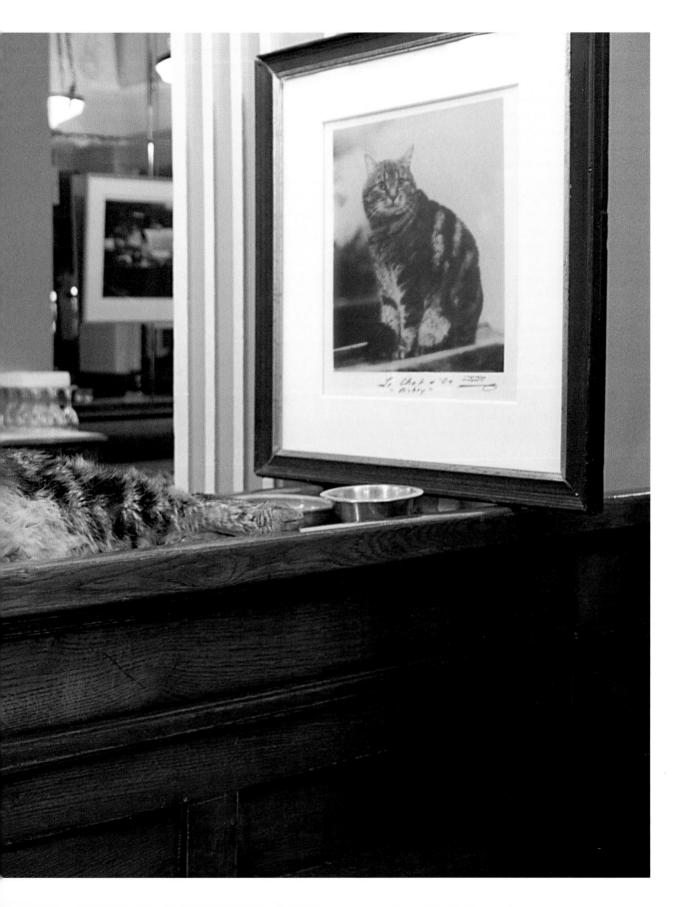

Mickey's fame eventually spread internationally, and on any given day, tourists would stop in to visit and photograph him. "Sometimes I think being Le Select's cat has gone to his head," a patron once remarked. "He received postcards and even care packages from places as far away as Nebraska," recounts Frédéric. "Someone once left him a rose."

Regular customers and the staff would vie for his attention, treating him with affection and respect. Every day, the crime writer Gilles Bornais would bring him a special blanket that Mickey favored for afternoon naps. "Sshh, don't wake him; he's dreaming," a regular would whisper.

Mickey's habits changed somewhat with age—in his younger days he used to go off during the daytime to find lunch somewhere along the nearby rue Stanislas, but in later years he remained closer to home and took all his meals at Le Select. Most days he would stick to dry cat food with tidbits of chicken and fish—he wasn't much of a red meat–eater—and once in a while he would enjoy a lick of Chantilly cream.

The only time Mickey was not a fixture at the bar was when Le Select held its annual Christmas party, and he would take cover in the office until the festivities were over. The next day he would be back at his post on the bar.

When Mickey died at twenty-two years old, the staff decided to break the news to their regulars slowly, and for a while the waiters had less of a spring in their step as they joined in with the clients to swap Mickey anecdotes. But after a few months, the staff welcomed not one but two Mickey successors, when a duo of tiny sisters arrived from the French countryside. "It was important that they be different from Mickey," explains Frédéric. After some bickering among the staff about the choice of names, the siblings were christened after two much-admired Montparnasse celebrities: Zelda, after F. Scott Fitzgerald's wife, and Youki, after Japanese painter Tsuguharu Foujita's model and future wife.

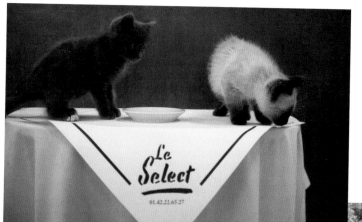

Parisian cemeteries are filled with works of art and the Montparnasse cemetery is no exception. Artist Niki de Saint Phalle created this giant cat in mosaic (below) for her assistant and friend Ricardo, who died in 1989.

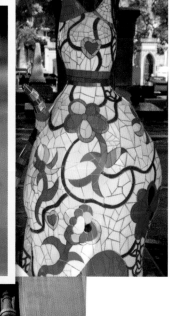

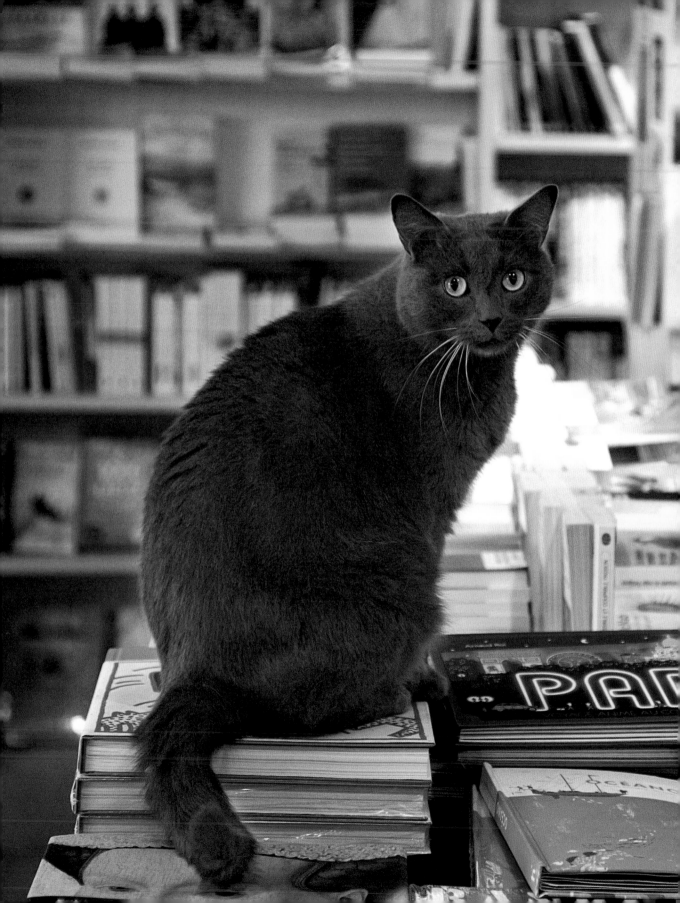

The rue du Faubourg-Saint-Antoine is one of the oldest avenues in Paris and has been a nucleus for artisans and manufacturing since the twelfth century. The courtyards and passageways off this main artery were once filled with workshops—some are still in operation—and they are testament to the hundreds of craftsmen who worked in the area making furniture, in particular for the royal courts. Many of the building entries are disproportionately high, with period lamps lining the passageways, built for when horse-drawn carriages would arrive.

Faced with the creeping gentrification of the nearby Bastille area, the neighborhood has fought hard to retain the atmosphere of its artisanal past. Page 189, an independent bookshop, opened in 1990 and is a polestar in the lively and creative area, mindful of keeping a link to its past.

One step down from street level, Page 189 has low ceilings with exposed beams. Long wooden tables with books neatly stacked on them line the center of the shop. Photographs of writers—Samuel Beckett, Marguerite Duras, and Edward Gorey (surrounded by his cats)—decorate the walls, along with an "I (heart) Dostoevsky" bumper sticker. On most days, a husky gray cat with green eyes sits bolt upright on the table closest to the register, watching the customers come in and out of the shop. Alternately, he naps on the larger photography books on another table. Arthur, named in homage

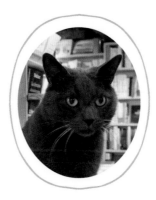

to Rimbaud, the French poet and one of the founders of symbolism, has lived in the shop since 2009. Owner Alain Caron and his partner Corinne Matras had just lost two longtime bookshop cats to old age, when a friend brought them Arthur, who had been found in a cornfield in the country.

"Arthur, most of all, cares about the bookshop," says Alain. But Arthur does have a best friend, Quignard (for French writer Pascal Quignard), a black-and-white cat who belongs to musician neighbors from the same building. Together, Arthur and Quignard explore the neighborhood, exiting either through the front door of the shop or the residential entrance to the building. The back of the bookshop, which is the children's book section, opens onto the building's courtyard so that the cats can come and go as they please. "Together they've doubled their territory," comments Alain.

Page 189 regularly holds book signings with authors such as Dominique Fernandez, Jim Harrison, or James Ellroy. "Arthur is always there for the events. He tests the writer's chair, then the table where the books will be signed. He wants to be with the author," says Corinne. "Most authors like it. Books and cats go well together."

Some of Page 189's booksellers disagree. They claim that when Arthur has dirty paws he walks intentionally on books by publishers such as P.O.L., Minuit, or Gallimard, the covers of which are traditionally white or cream.

"He has us all trained perfectly," comments Corinne. "The neighbors all know who he is and open the door for him. The baker took him home once when he was locked outside. He sits in the window and does social networking. He has become a central figure in our bookshop."

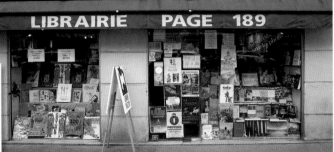

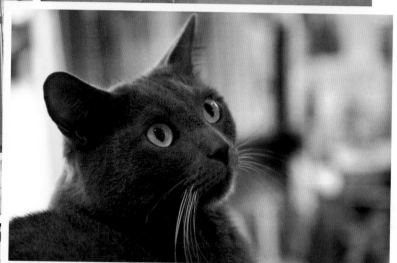

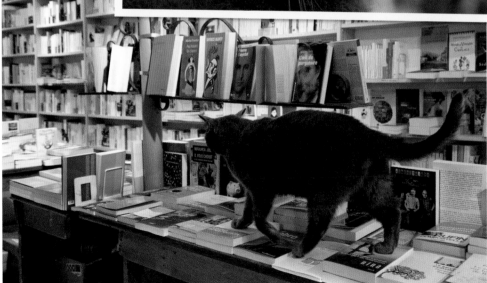

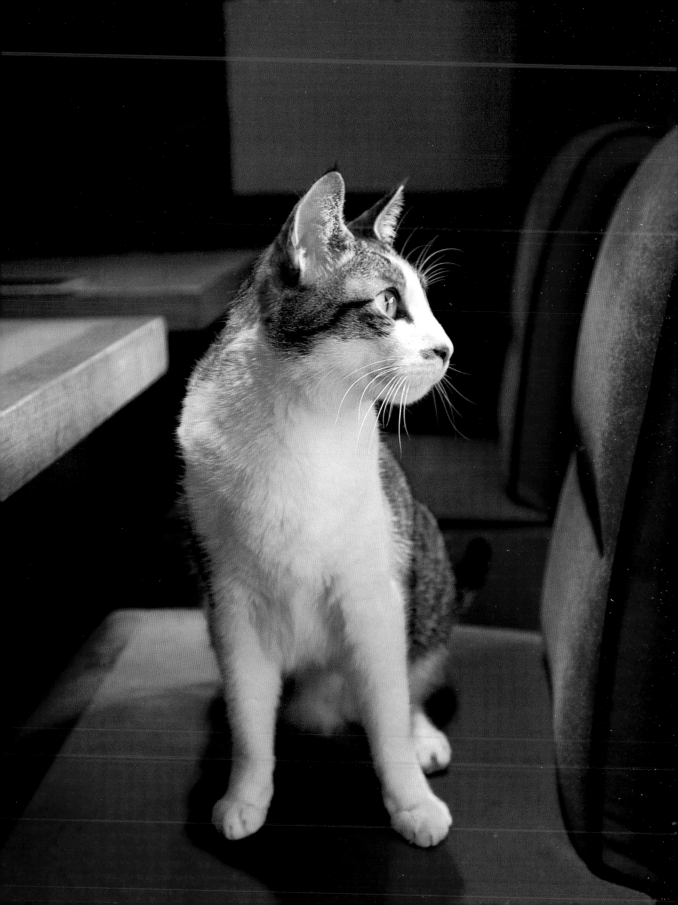

RUCQUETTE
CAFÉ RUC
159, rue Saint-Honoré 75001 Paris
+33 1 42 60 97 54

The crossroads at which the sleek Café RUC is located is a dizzying combination of intense traffic, historical landmarks, and entranceways to Parisian treasures. With one's back to the café, to the left is the Comédie-Française theater, founded during Louis XIV's reign; behind it lie the Palais Royal Gardens, part of a royal palace commissioned by Cardinal Richelieu in 1633. Directly opposite the café is the nineteenth-century Hôtel du Louvre where the impressionist Camille Pissarro painted a number of well-known canvases from his window, and to the right are the stone arches of the Pavillon Rohan that lead toward the Louvre museum complex. The striking Palais Royal-Musée du Louvre metro station exit at place Colette is visible from the café as well: in 2000, for the one-hundredth anniversary of the station, artist Jean-Michel Othoniel transformed it into two aluminum cupolas adorned with multicolored glass and silver beads that he called the Kiosque des Noctambules (the Night Owl's Kiosk). Othoniel's cupolas are one of three contemporary structures in the area that are integrated into classical architecture—the others are I.M. Pei's glass and steel pyramids at the Louvre and Daniel Buren's black-and-white striped columns in the Palais Royal's court of honor.

All these landmarks, among Paris's most visited, can be admired from behind a full-length glass window by Rucquette. She has white fur on her chest and tiger stripes on her back and face—in particular over one eye, like a pirate's patch. From her hushed, elegant home inside the Café RUC, she can observe the outdoor bustle from the black-trimmed, padded red velvet chairs by the windows. Relaxed in her plush surroundings,

where pleated lampshades give off a soft golden light and the black marble tiles on the floor are covered in thick patterned carpets, Rucquette, who is especially sweet-natured and calm, has not always had it so easy. She began her current life at the café in 2007 after she was adopted from an animal shelter where she had been brought in as a battered cat; she still limps. Sylvain Deniaux, a waiter who has worked at the RUC since 2001, says customers stop by in the morning on their way to work just to pet her. Occasionally a patron will give her flakes from a croissant. Otherwise, Rucquette is a gentle presence, curling up next to the regulars, who include actors Guillaume Canet, Jean-Paul Belmondo, and Catherine Deneuve. On the walls of the RUC, there are autographed black-and-white photographs of members of the Comédie-Française's troupe, a lineage that reaches back to the seventeenth century when the playwright and actor Molière directed the theater. Archives at the theater show that in 1829, and for the following thirty years, a cat was added to the general expenses each month: the linen supervisor always kept a cat so that the costumes, which were starched and thus appealing to mice, would be protected from them.

Rucquette lives a mere thirty feet (10 m) away from French author Colette's apartment, which overlooked the beautiful Palais Royal Gardens. Colette lived in this apartment from 1938 until 1954 and spent most of her life surrounded by cats, whom she wrote and sang about. Colette's friend and fellow novelist, artist, playwright, and filmmaker Jean Cocteau, lived just around the corner from her and shared Colette's passion for cats—he drew them, sculpted them, and wrote poems about them.

In a collection of Colette's best texts on cats, she famously wrote in the preface, "There are no ordinary cats."

The author Colette could
look out of her window
at the beautiful Palais Royal
Gardens (bottom, left), which
have nearly five hundred trees
lining the walkways,
as well as two vast flowerbeds
separated by a large circular
pool and fountain.

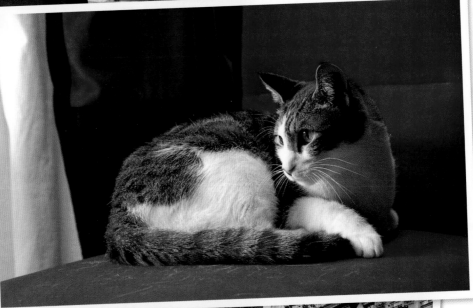

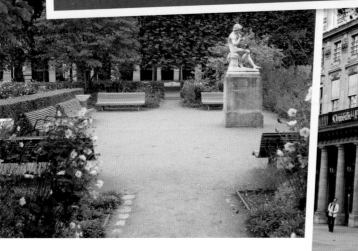

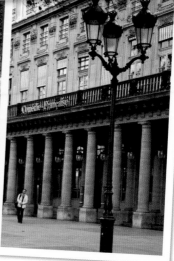

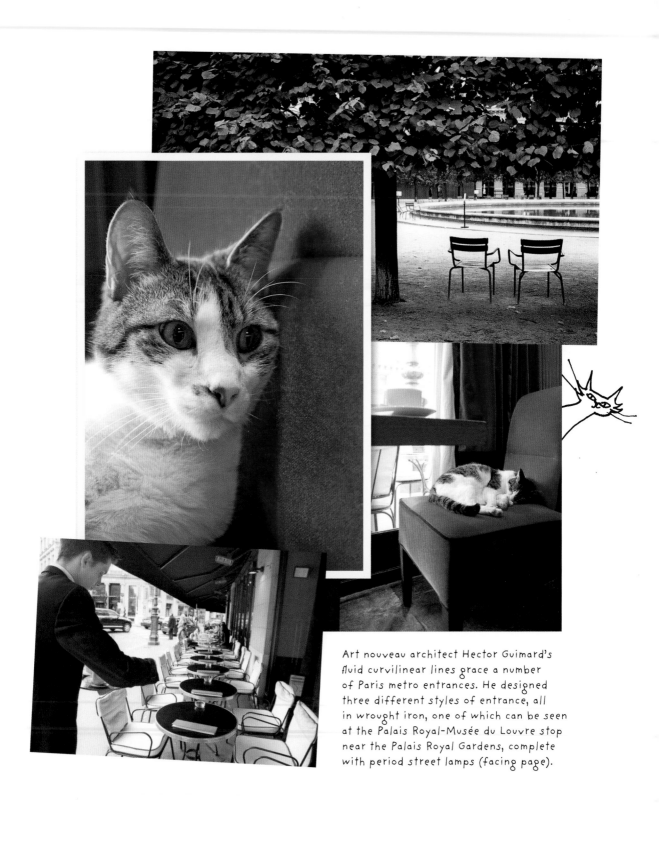

Art nouveau architect Hector Guimard's fluid curvilinear lines grace a number of Paris metro entrances. He designed three different styles of entrance, all in wrought iron, one of which can be seen at the Palais Royal-Musée du Louvre stop near the Palais Royal Gardens, complete with period street lamps (facing page).

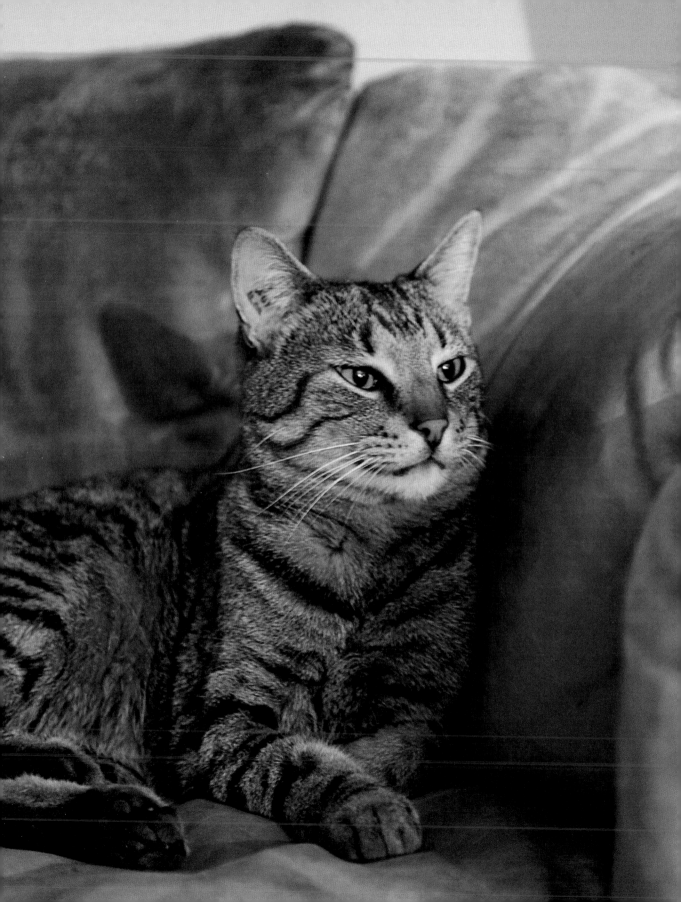

Le Carillon
18, rue Alibert 75010 Paris
+33 1 42 39 81 88

The area around the Canal Saint Martin—immortalized in the 2001 film *Amélie* (*Le Fabuleux Destin d'Amélie Poulain*), when the actress Audrey Tautou, clad in a red dress, skips stones across the canal—has gradually transformed from a working-class neighborhood into a trendy one, with pricey boutiques, bars, and restaurants now lining the streets along the canal. Just off the canal on a side street, the traditional Le Carillon café represents a crossroads of this social transformation—it is just as popular with an older crowd that has lived in the neighborhood for decades as it is with the newcomer hipsters and bobos (bourgeois bohemians). Together they drink aperitifs and shell roasted peanuts as they lounge on the eclectic mix of chairs—some classical wicker, others old school chairs with red metal frames—which are placed around rickety wooden tables outside. Inside, soft jazz plays on the radio throughout the day, contributing to the easygoing, low-key atmosphere.

Le Carillon has been in the hands of the same family for forty years and is managed by the highly energetic Hacén Kemache who also administers to Milou, a pretty tabby with a fiercely independent streak.

Milou sauntered into Le Carillon one day and adopted it as her home. She is perfectly at ease inside the café with its wood paneling, mosaic floors in 1970s tones, and

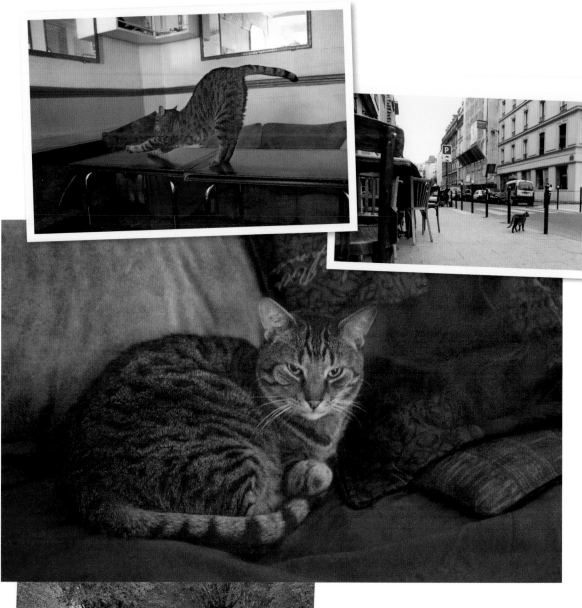

Nearly three miles long (4.5 km), with nine
locks, the Canal Saint Martin (left)
runs partially underground. It is lined with
chestnut and plane trees, interspersed
with footbridges, and has often provided
the backdrop for movies.

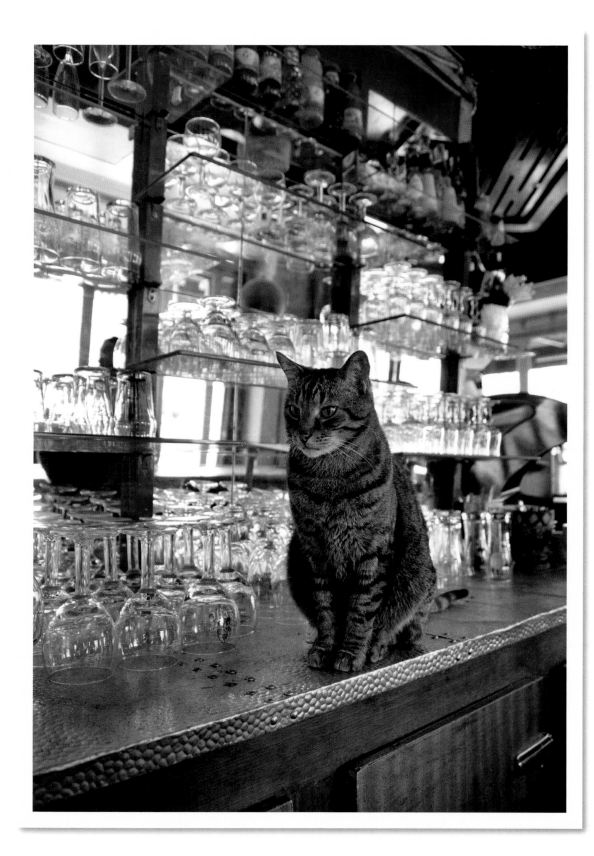

ramshackle but comfortable furniture—she favors in particular the faux leather sofa in the back room where she likes to sleep on an orange plaid cushion.

Footloose Milou doesn't really take after her namesake—Tintin's faithful wire fox terrier, known in English as Snowy—but Le Carillon wouldn't be the same without her, say the regulars. She'll occasionally sit on the zinc bar and mix with the patrons while they drink their morning coffee, and then she is off—mainly to explore the garden inside the nearby seventeenth-century Saint-Louis Hospital, founded by the Bourbon king Henri IV. Milou's choice of garden is a fine one—set in the inner courtyard of the hospital complex, it is one of the least known in Paris and also one of the most beautiful. The same engineer who drew up the plans for the hospital and grounds also designed the place des Vosges. Work began in 1607 after Henri IV laid the first stone for what would become the Saint-Louis chapel, which is still in use, with the royal ciphers of Henri IV and his wife, Marie de' Medici, above the entrance. Slightly farther afield, Milou has the choice of another garden in the Convent of the Recollets, for which Marie de' Medici laid the first stone in 1614.

Despite all the possibilities for exploration in the neighborhood, Milou always comes back to Le Carillon before closing time at 2 a.m. "She has an inner clock," comments the barman, Koko Adjem. Opening time is 7 a.m., and what she really likes for breakfast, says Koko, are a few nice slices of ham.

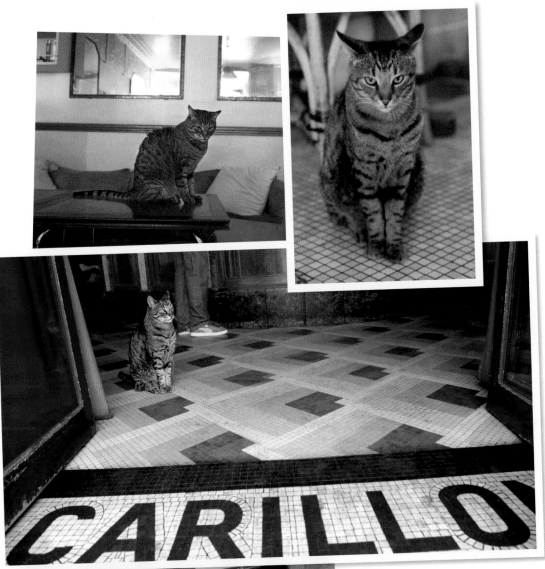

The trend for mosaic floors in Paris cafés began at the turn of the twentieth century with the advent of the art nouveau style. Usually in stoneware, these tiny squares measuring less than an inch (2 cm) are extremely sturdy.

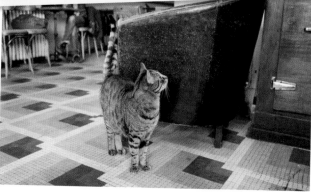

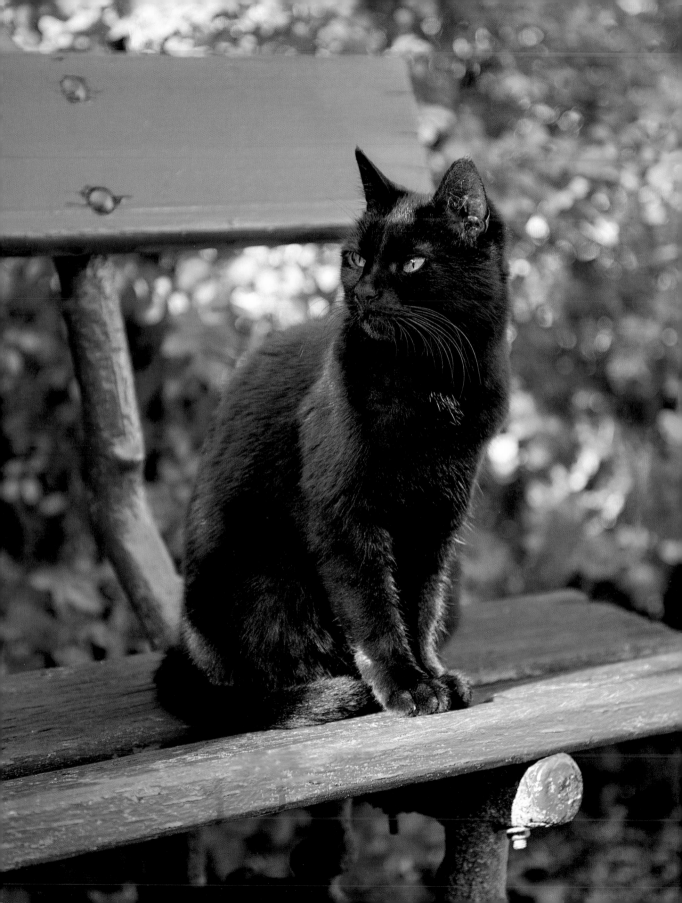

The neighborhood of Montmartre sits atop a hill in northern Paris. Once a rural village with narrow streets, cottages, windmills, and vineyards, it became part of Paris in 1860 and soon, because it was inexpensive, drew students and artists of all sorts. Cafés, dance halls, and cabarets grew rapidly around the area and for a while, between the late nineteenth and early twentieth centuries, the area was vibrant with artistic activity. Perhaps the best place to get a feel for what bohemian Montmartre was like is in the Musée de Montmartre, surprisingly calm after the crush of the place du Tertre. Surrounded by three gardens and the one remaining vineyard in Montmartre, the museum is in a seventeenth-century manor, the oldest house in the area, where Roze de Rosimond, an actor in Molière's theater company, once lived.

To get to the museum, visitors cross the first garden, walking under a pergola covered with wild roses. To their right, a quince tree bows low, supported by a graceful metal sculpture of a lyre; a bed of wildflowers borders a whitewashed wall behind it. To the left are two benches in an L-shape, painted the traditional dark green of Paris benches, and on most days, Salis, the pint-sized, jet-black museum cat lies, sphinx-like, on one of them.

Salis is named after Rodolphe Salis, one of the preeminent figures of Paris's Belle Epoque and founder of the celebrated cabaret Le Chat Noir (The Black Cat), which he opened in 1881, hanging a distinctive painted metal sign of a black cat on a crescent moon by Adolphe Willette outside. Théophile-Alexandre Steinlen's equally famous lithograph of a black cat was painted for one of Salis's cabaret road shows in 1896. Salis was the master of ceremonies in his cabaret, slinging tongue-in-cheek comments to his audience while presenting theater performances, music recitals, and readings that made his cabaret an essential part of the avant-garde artistic and literary scene.

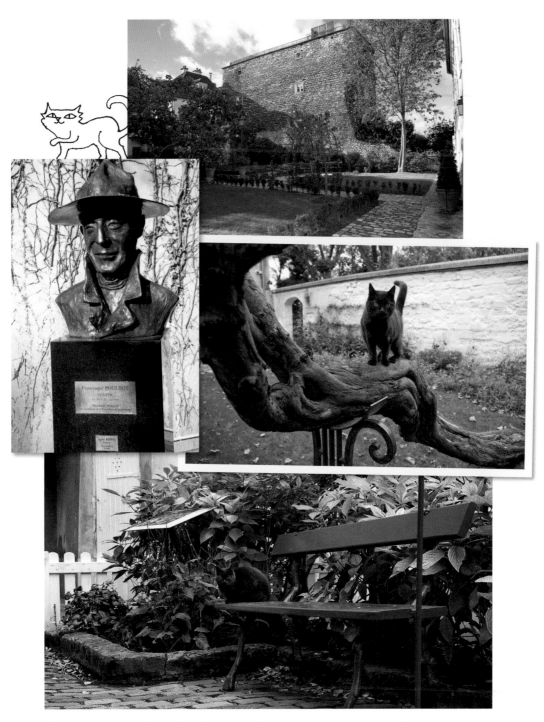

Illustrator and designer Francisque Poulbot was one of Montmartre's most emblematic figures. The bronze bust of Poulbot (center, left) was inaugurated in the Montmartre museum's garden in 2012.

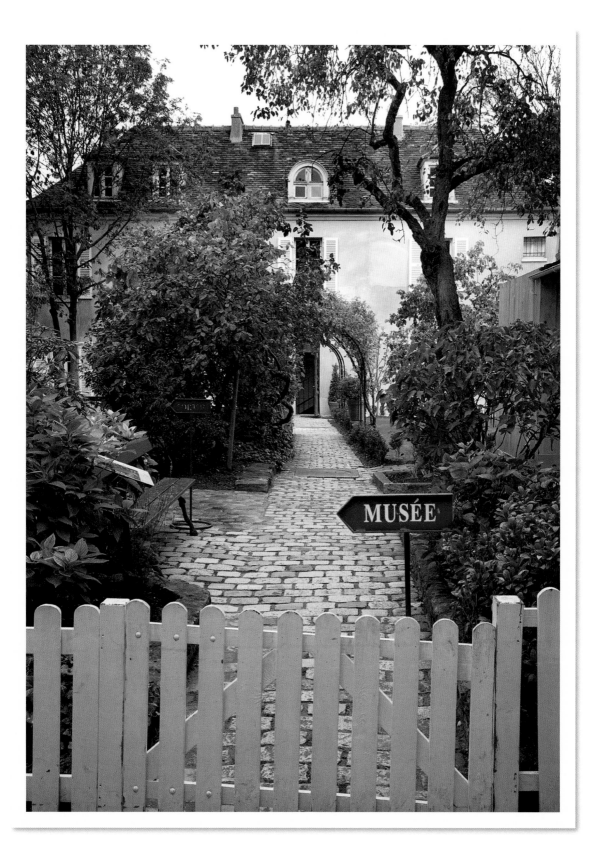

The Musée de Montmartre's collection includes posters, paintings, and photographs that recreate the free-spirited atmosphere of the time, and it has a special room dedicated to Le Chat Noir's celebrated shadow plays.

No one at the museum is quite sure when Salis the cat showed up, but the staff agrees that it must have been around 2007. He spends most of his days in the garden and sleeps in a cloth basket in a cupboard outside, near the museum entrance. The guards and staff feed him three times a day, and management has a budget for his upkeep. "Everyone thinks we did it on purpose, to have a black cat," says Karelle Le Queré, the marketing director. "But he's the one who decided he liked it here. He acts like a star, and people love him."

The museum's manor house and adjacent eighteenth-century Maison Demarne served as dormitories and studios for numerous artists, writers, and musicians, including Raoul Dufy, Suzanne Valadon, and her son Maurice Utrillo. In the early days of impressionism, Auguste Renoir was one of the first residents, and it was here that he completed several of his well-known paintings, including his 1876 *La Balançoire* (*The Swing*). The model for the swing still exists today, hanging from a tree near a pond filled with lotus flowers. Salis likes to rub his head against its wooden slats before running down the steps past a bust of Francisque Poulbot, an illustrator and integral part of the Montmartre scene, toward the lower garden. A large evergreen tree towers over a platform from which there is a panoramic view of the vineyard, the surrounding houses, and the infamous Au Lapin Agile cabaret, still in operation, where writers, poets, musicians, anarchists, and pimps all made merry. Picasso's 1905 oil painting *At the Lapin Agile*, now in the Metropolitan Museum of Art, graced the walls of the cabaret for seven years.

While the fact that the museum cat is black and called Salis delights visitors, he is apparently part of a long Montmartre tradition—French dramatist Maurice Donnay, who wrote plays for the original Le Chat Noir, recalled in his memoirs seeing a live black cat on the premises of the cabaret.

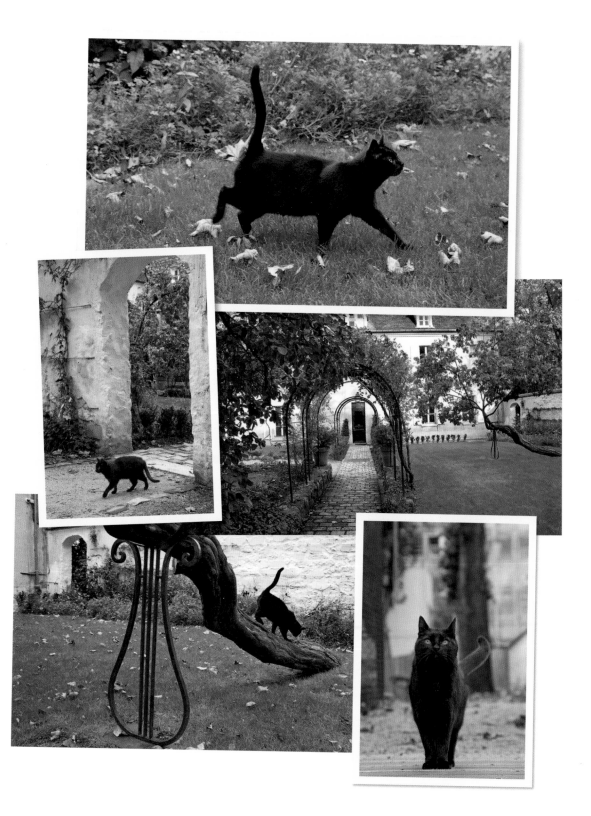

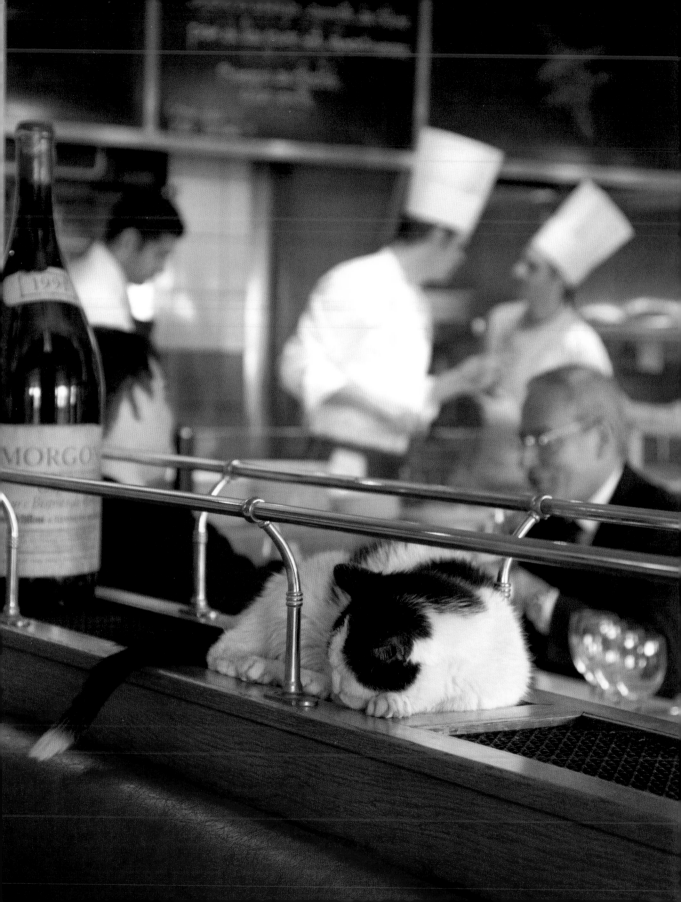

Several bridges down from the crush of tourists around Notre Dame Cathedral, La Rôtisserie is the casual-dining subsidiary of the renowned and very formal La Tour d'Argent restaurant across the street. Founded in the sixteenth century, La Tour d'Argent was a favorite among kings and dukes, and the views of Paris from its sixth-floor restaurant inspired the makers of the animated film *Ratatouille*. Though far less formal, La Rôtisserie is no less gleaming and pristine. Yellow-and-white checkered tablecloths, red leather banquettes, an open rotisserie, and waiters in Bordeaux-colored aprons all make for a cozy atmosphere. A wall displays photographs of clients, such as the French journalists Bernard Pivot and Claude Sarraute, but also of a plump black-and-white cat yawning widely, lying on a table next to the salt and pepper shakers and a mustard pot. The cat is Beaujolais, the restaurant's mascot, now a mature feline with slightly unkempt fur and wise green eyes.

Named for the light, easy-to-drink wine, Beaujolais the cat is similarly approachable and easygoing. Appropriately enough, he used to sleep on top of the wine barrels at the entrance to the restaurant—La Rôtisserie is known for its selection of thirty to forty wines chosen from La Tour d'Argent's celebrated wine cellar—but as an older gentleman, he has since migrated to warmer areas in the restaurant. He now favors the wooden shelf between two facing banquettes, slightly above customers' shoulder

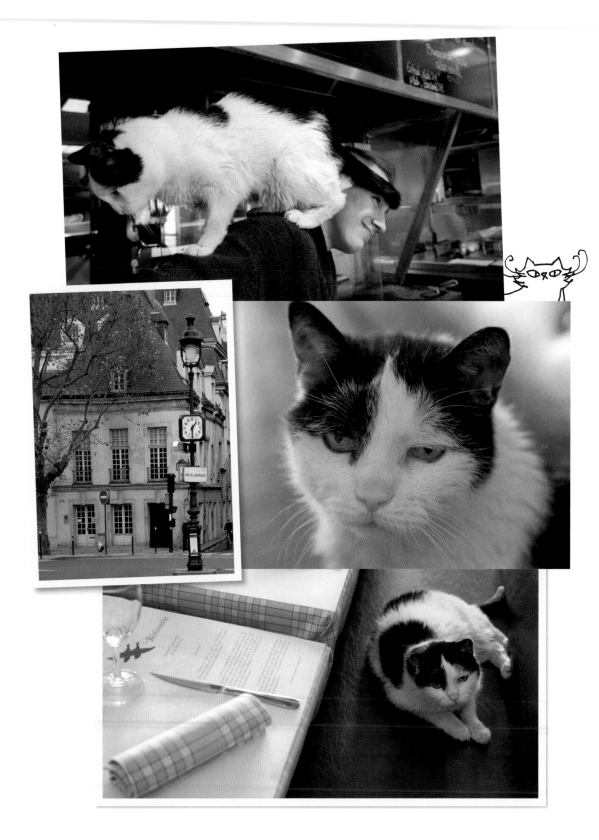

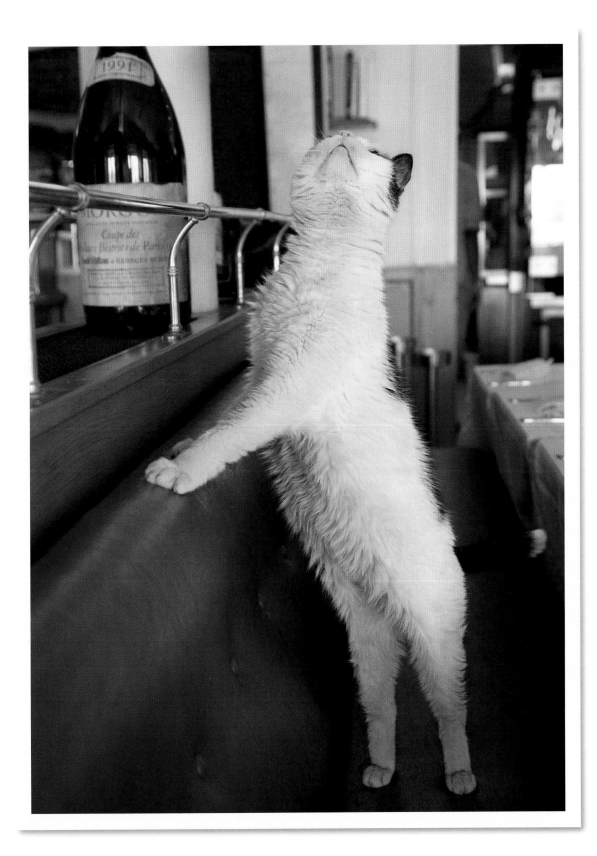

level, or the comfortable leather banquettes themselves, one stretch of which was recently replaced because Beaujolais used it too often as a scratching post.

Patricia Bauthamy, the codirector, has been with La Rôtisserie since 1996, several months before the owners decided to get a cat—the restaurant had been renovated and had a mouse problem. "He did his job," says Patricia, "but by then the clients loved him so much we decided to keep him." He was once nearly lost as a kitten, she recounts, still upset by the memory. He had climbed inside a customer's handbag and had fallen asleep, discovered only as the customer was leaving and lifted her heavier-than-usual bag.

Although Beaujolais is fed first thing in the morning, he also has a snack with the staff when they eat their midday meal before the lunch service. During restaurant hours, the waiters are vigilant and nimble, as Beaujolais may be underfoot. On a sunny day, he ambles outside to the end of the veranda to nibble on the grass growing through the cracks in the pavement opposite the Pont de la Tournelle, where the art deco–style statue of Saint Geneviève, the patron saint of Paris who protected the city from Attila and the Huns in the fifth century, gazes out over the Seine. Like Mickey at Le Select, Beaujolais has achieved star status. Patricia soon discovered, upon launching the restaurant's Facebook page, that people mostly wanted her to post photographs of Beaujolais (she remains resistant). An American client brings him a toy every time she comes to Paris. During the summer, he loves to lick ice cubes in drinks—and most customers allow him to do so. One client takes both his noon and evening meals at La Rôtisserie, and Beaujolais waits for him at his regular table.

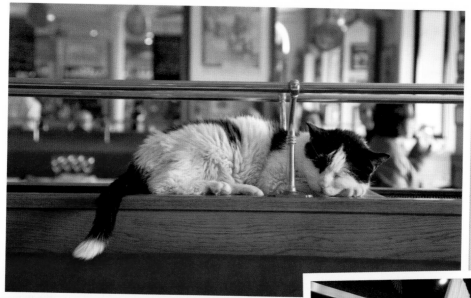

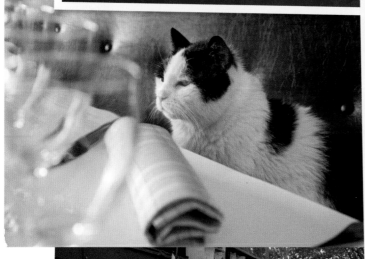

The chef, Sébastien Devos (above), handling Beaujolais much like a sirloin steak, the cat's favorite dish.

Reproductions of Steinlen's celebrated lithograph advertising Le Chat Noir cabaret on tour can be found at the nearby *bouquinistes* (left).

ACKNOWLEDGMENTS

The authors would like to thank their
friends who helped with cat sightings:
Maria Janko, Beatrix de Koster,
Gérard Étienne Mathey, Michèle Mathieu,
Gillian Whitcomb, and La Maison du Vitrail.

Thank you to Mitch Albert,
Stephanie Araud, our agent
Suresh Ariaratnam, and our fantastic
editors and the team at Flammarion:
Sophy Thompson, Kate Mascaro,
Gaëlle Lassée, and Helen Adedotun.

Special thanks to Odile Oudin
and her cats—Chanel, Kenzo, and Dior—
and the team at Misenflore.

Last but not least, we would
like to thank the cats themselves
for their patience and beauty.

Design: Isabelle Ducat
Illustrations: Vanessa Corlay
Copyediting: Karen Traikovich
Proofreading: Helen Downey
Color Separation: Bussière, Paris
Printed in Portugal by Printer Portuguesa.

Simultaneously published in French as *Chats Parisiens*
© Flammarion, S.A., Paris, 2014

English-language edition
© Flammarion, S.A., Paris, 2014

editions.flammarion.com

14 15 16 4 3 2

ISBN: 978-2-08-020174-4

Dépôt légal: 04/2014